Mondrian

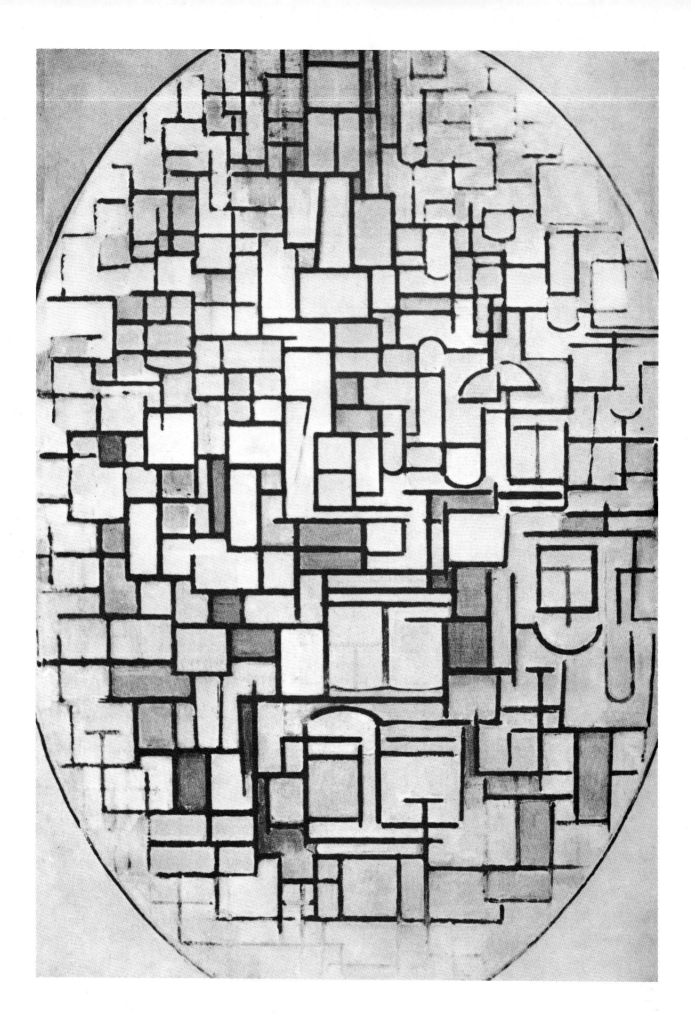

Oval Composition (Tableau III)/1914
Oil on canvas, 55 3/8 × 40 1/8"
Stedelijk Museum, Amsterdam

Piet Mondrian

Text by

Hans L.C. Jaffé

Harry N. Abrams, Inc., Publishers, New York

ISBN 0-8109-1413-1
Library of Congress Catalog Card Number: 85-71500

Published in 1985 by Harry N. Abrams, Incorporated, New York.
Also published in a leatherbound edition for The Easton Press,
Norwalk, Connecticut. All rights reserved. This is a concise
edition of Hans L.C. Jaffé's *Mondrian,* originally published
in 1969. No part of the contents of this book may be
reproduced without the written permission of the publishers

Printed and bound in Japan

Contents

Colorplates

Mondrian

Working within the austere limits of the straight line, the right angle, the three primary colors (red, yellow, and blue), and the three primary non-colors (white, gray, and black), Piet Mondrian created a style of painting that is at once personal and universal, inimitable despite its seeming simplicity, and of seminal influence on twentieth-century painting, sculpture, architecture, and the applied arts. As a pioneer and founder of abstract art, Mondrian was the undaunted, completely selfless champion of objectivity. The subjective "law of inner necessity" which governed the work of his great contemporary and fellow abstractionist, Vasily Kandinsky, was alien to everything Mondrian was striving for. He called his approach the new plastics, or neo-plasticism, and sought through it to explore and express "pure reality," the "unity resulting from the equivalence of opposites," by "the abolition of all particular form." At the same time, he wished his art to serve as a beacon lighting mankind's way to the future.

Mondrian's own path as an artist is fascinating as only a single-minded quest can be. His was a search for a goal that he saw but vaguely at first and then clearly and distinctly; the attainment of that goal, of a solution to the problems, artistic and human, confronting him; and thereafter no stand-still, no veering in other directions, but a continuation, a constant refinement and ever-new achievement of the solution. As a result, the second half of his creative career is made up of an amazing series of masterpieces, each work evolving logically and consistently from those that preceded it. This straightforward evolutionary character was indeed the essence of Mondrian's art from the very beginning, as was brilliantly illustrated in the large retrospective exhibition of his entire *oeuvre* held in Toronto, Philadelphia, and The Hague in 1966. In his autobiographical notes, Mondrian summed up his philosophy of life and art in two words: "Always further."

Mondrian subordinated his entire life to his art. Precisely for that reason, the facts of his biography are of secondary importance and can be related rapidly.

Pieter Cornelis Mondriaan was born in the central Nether-

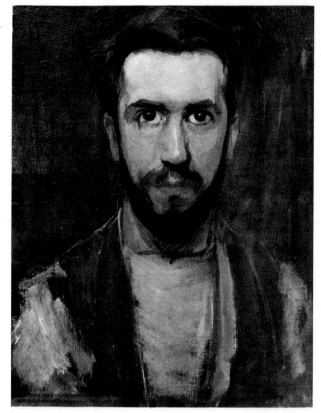

2
Self-Portrait/c. 1900
Oil on canvas, 19 1/4 × 15"
Sidney Janis Gallery, New York

lands town of Amersfoort on March 7, 1872, the second child and oldest son of Pieter Cornelis Mondriaan, Sr. (1839–1915), and his wife, Johanna Christina Mondriaan, *née* de Kok (1839–1905). Headmaster of the Dutch Reformed elementary school in Amersfoort, the elder Mondriaan was a devout, strait-laced Calvinist. At the same time, he seems to have been a gifted and enthusiastic amateur artist, whose hobby of making pictures without doubt influenced his son's subsequent choice of art as a career.

Piet Mondrian spent his first eight years in the strict Reformed milieu of Amersfoort. In April 1880 his family moved farther east, to the town of Winterswijk near the German border, where his father had been appointed head of the Christian elementary school. There Mondrian completed his schooling and declared his intention of becoming an artist. His family regarded such a career as too risky, however, and insisted that Piet first obtain his certificate as a drawing teacher, so that he would at least have teaching to fall back on should his other ambitions fail. In Winterswijk young Mondrian worked at preparing for his examinations, with the help of his father and occasional assistance from his uncle, Frits Mondriaan (1853–1932), a professional artist who had studied under Willem Maris and become one of the numerous followers of the Hague school.

In 1889 Mondrian won his license to teach drawing in primary schools, and three years later, in 1892, the certificate entitling him to teach in secondary schools. Now that he had met his family's conditions, he could set out upon the road to an artistic career. The first steps on this road were probably the few lessons he took at this time from Johan Braet van Ueberfeldt, an elderly and rather traditional painter in the nearby town of Doetinchem, but most likely the only recognized artist in the immediate vicinity. Mondrian realized that he must go further afield, however, and he chose the best school available in the Netherlands for his advanced education. In the autumn of 1892 he registered at the National Academy of Art in Amsterdam, an institution which had become renowned under its director, August Allebé. George Hendrik Breitner, for example, who in the 1880s was the acknowledged leader of a forward-driving generation, had no hesitation about completing his training as a painter at the Academy, although he was almost thirty when he enrolled and had himself given instruction in drawing in Leiden and Rotterdam. Allebé was justly famed as a teacher, for he maintained high and demanding standards. He was, to be sure, a realist through and through,

with an unwavering faith in visual observation, down to the smallest detail; but in forming a new generation of artists he brought to bear a profound knowledge of the old schools and of the coloristic and compositional techniques of earlier masters.

While studying in Amsterdam, Mondrian also found opportunity to join the Kunstliefde (Love of Art) Society in Utrecht. There, in 1893, he exhibited his work for the first time in public. During the next year he attended evening classes at the Academy and joined the Arti et Amicitiae and St. Lucas artist societies in Amsterdam. In 1896 he continued his evening classes at the Academy and gradually came to regard his training as completed: in 1897 he exhibited at Arti et Amicitiae, and in 1898 at St. Lucas. The latter year also marks the beginning of his friendship with A. P. van den Briel, a friendship that was severed only by World War II and Mondrian's death in the United States. In 1899 he did a large ceiling painting in a house on an Amsterdam canal, a commission that he probably construed as recognition of his unfolding talent. From the same period dates his

3
Mondrian in his Amsterdam studio/c. 1905

4
Self-Portrait/1908/9
Drawing, charcoal on paper, 11 3/4 × 9 3/4"
Collection S. B. Slijper, Blaricum, Netherlands

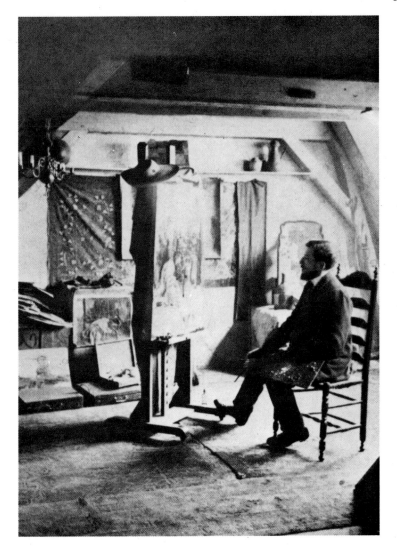

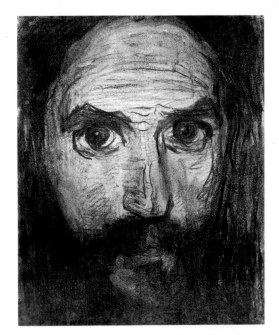

friendship with Simon Maris, son of the Hague painter Willem Maris. The two young men traveled in Spain in 1901, but nowhere in Mondrian's work or in any of his writings can trace of this journey be found. In the same year Mondrian applied for the Dutch Prix de Rome; he was admitted to the competition but was not one of the few chosen for the final round. Two years later, however, he won the Willink van Collen Prize of the Arti et Amicitiae Society, with a still life. To the artist, who had just passed his thirty-first birthday, this encouraging award must have signified the beginning of his professional life as an artist.

For the next few years Mondrian was engaged almost exclusively in painting landscapes. This activity also determined his external circumstances: in 1903 he was in the eastern part of North Brabant, near Uden, with his friend van den Briel; he spent almost all of 1904 in the same district, working in the deepest solitude; 1905 found him back in Amsterdam, from which he ventured forth to paint a series of landscapes in the countryside near by, along the Amstel and the Gein rivers. During these years he also

worked for a time, at the invitation of a friend, the painter Albert Hulshoff Pol, in the village of Oele, some twenty miles north of Winterswijk. In 1908 Mondrian went to Zeeland for the first time, staying in Domburg on Walcheren Island, a popular vacation place for Dutch artists. Jan Toorop, the leader of the Dutch symbolists and an advocate of Jugendstil, went there regularly, as did Mondrian for the next five years and again after his return to the Netherlands during the first world war. These Zeeland visits left distinct traces on his work.

In 1909 Mondrian joined the Netherlands Theosophical Society, whose esoteric doctrines were at that time attracting considerable attention, particularly in artistic and intellectual circles. To Mondrian this step meant a definite break with the orthodox Christianity of his parents and an attempt to discover for himself, through the neoplatonic and pantheistic ideas propounded by the Society, a solution to the mystery of the world and of human existence.

The first retrospective showing of Mondrian's work, along with that of Cornelis Spoor and Jan Sluijters, also took place

5
Self-Portrait/1908/9
Drawing, charcoal on paper, 11 3/4 × 10 1/8"
Collection S. B. Slijper, Blaricum, Netherlands

6
Mondrian/1908

7
Self-Portrait/c. 1908
Drawing, charcoal on cardboard, 31 1/2 × 21 3/4"
Collection S. B. Slijper, Blaricum, Netherlands

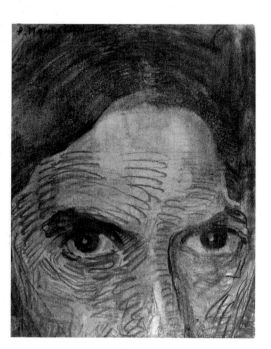

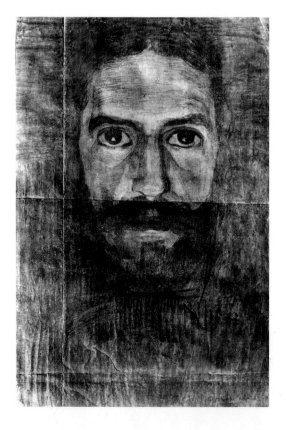

in 1909, in the Stedelijk Museum of Amsterdam. The exhibition was a remarkable success, and Mondrian was recognized as one of the outstanding figures in the new art of the Netherlands. Further confirmation of his growing reputation was his selection in the same year as an auxiliary member and in 1910 as a full member of the St. Lucas jury. His works in the spring 1910 exhibition of this society brought him renewed acclaim, albeit lashed with a strong dose of journalistic criticism. In the fall of that year, with Conrad Kickert, Jan Sluijters, and Jan Toorop, he was on the founding committee of the Moderne Kunstkring (Modern Art Circle), conceived and established by Kickert as an avant-garde association. Mondrian, now a leader in Dutch art, sent one of his canvases to the spring salon of the Indépendants in Paris in 1911. Some months later, in October and November, the Moderne Kunstkring held its first exhibition of international art, honoring Paul Cézanne and comprising works by the most advanced painters of Paris and Amsterdam. Among the Paris items were cubist paintings by Braque and Picasso. As far as is known, Mon-

8
Self-Portrait/ 1913
Drawing, charcoal on paper, 19 1/2 × 29"
Gemeentemuseum, The Hague (Collection S. B. Slijper, on loan)

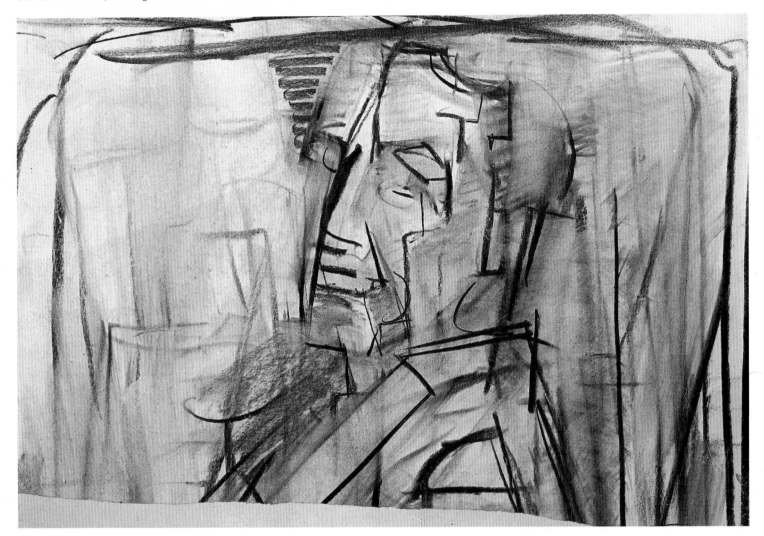

drian had never before seen the modern art of Paris in the original, and what he now saw altered his whole life. Presumably under the profound impression of the cubist works, he gave up his residence in Amsterdam in December 1911 with the purpose of going to Paris to work.

In May 1912 Mondrian registered in the French capital as living at 26, rue du Départ. He exhibited both with the Indépendants in Paris and with the Moderne Kunstkring in Amsterdam. And, perhaps to symbolize his new step forward, he changed the spelling of his name, dropping the second "a." That his work was examined with intelligence and interest in Paris is evidenced by Guillaume Apollinaire's review of the 1913 Salon des Indépendants, in which Mondrian participated. The poet-critic describes the Dutch painter as the "offspring" but not an imitator of the cubists, with a personality wholly his own. In the same year Mondrian also exhibited at the Deutsche Herbstsalon in Berlin, organized by Herwarth Walden.

But this international fame came to an end in 1914. In the summer of that year Mondrian returned to the Netherlands from Paris, called back to the sickbed of his father, who was mortally ill and died the following year. Moreover, on August 4, 1914, German armies crossed into Belgium, and World War I began. Mondrian, who had left all his paintings and equipment in Paris, was caught in the neutral Netherlands until the end of hostilities more than four years later. At first he lived temporarily in Domburg and Amsterdam. Work of his was exhibited in the summer of 1914 at the Walrecht Gallery in The Hague. In 1915 he settled in Laren, a suburban community near Amsterdam long congenial to artists. There he met S. B. Slijper, who was to become his friend and patron and whose unparalleled collection of his early works is a lasting monument to the artist. In Laren, too, he became acquainted with the philosopher and theosophist, Dr. M. H. J. Schoenmaekers, whose writings he admired and owned. Indeed, he later adapted some of Schoenmaekers' ideas and even his terminology for his own purposes. A third important contact during this period was with Bart van der Leck (figure 10), a painter living in Laren and concerned with the same kind of problem confronting Mondrian: the

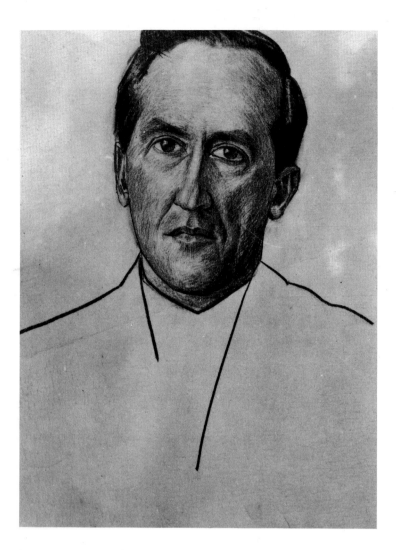

reduction of appearance to its artistic elements. Finally, through these Laren acquaintances, Mondrian met Theo van Doesburg (figure 11), a versatile artist, essayist, and critic, at that time just out of military service and full of ideas for founding an avant-garde magazine of the arts.

Van Doesburg discovered and rallied the support he was seeking in this rather amorphous Laren circle. With its help, and especially that of Mondrian, he was able to found his magazine and to launch that new movement in the visual arts which has come to be known as De Stijl—The Style. In the very first numbers of the magazine, which began publication in October 1917, we find Mondrian's basic essays on art, probably written in 1916 at Theo van Doesburg's instigation. Mondrian declares his complete support for the ideas of the group, in his work and in his personal attitude, and accordingly puts his signature to the first De Stijl manifesto, published in the November 1918 issue.

But he seemed not to feel quite at home in the Netherlands. As soon as circumstances permitted, he went back to Paris; his departure from Laren is listed in the municipal register as of July 14, 1919. In Paris Mondrian lived first at 5, rue de Coulmiers, and then again at his old address, 26, rue du Départ. The Paris art dealer Léonce Rosenberg, who was interested in the new plastic theories, published a French résumé of Mondrian's *De Stijl* essays under the title *Le Néo-Plasticisme.* The little book, issued in 1920, brought Mondrian's ideas to a somewhat wider audience. In 1922, on his fiftieth birthday, his friends Peter Alma, J. J. P. Oud, and S. B. Slijper organized a retrospective exposition of his work in the Stedelijk Museum in Amsterdam. Neither this show, however, nor the one at Léonce Rosenberg's in Paris in 1923 was able to produce any significant increase of interest in his work.

In 1925 Mondrian broke his connections with De Stijl, because he felt that Theo van Doesburg had definitively departed from the group's principles. From this time on he was even more alone, although some of his admirers in Germany and the United States began to draw attention to his work. Moreover, *Le Néo-Plasticisme* appeared in 1925 in German translation as a Bauhaus book, under the title

Paris, forced him out of London, where he had thought to be safe. In September 1940, in the midst of the blitz against London, he fled to New York, where he was welcomed by his friends Harry Holtzman, James Johnson Sweeney, and other admirers. He took a small studio at 353 East 52nd Street, at the corner of First Avenue. A group of friends soon formed around him, including, along with Holtzman and Sweeney, Charmion von Wiegand, Fritz Glarner, and Carl Holty. In January and February 1942, just before his seventieth birthday, he had a one-man show at the Valentine Dudensing Gallery, followed in March and April 1943 by a second exhibition of recent works. These were the first exhibitions of Mondrian's work by itself since the retrospective held in 1922 in honor of his fiftieth birthday.

In 1943 Mondrian moved to another studio at 15 East 59th Street, in the middle of the district where the art life of America is now concentrated. There he completed his last works, in particular his *Broadway Boogie-Woogie.* There too he worked on the painting of the *Victory Boogie-Woogie,* left incomplete at his death. At the end of January 1944 friends found Mondrian in his studio seriously ill with pneumonia. He was taken to a hospital, but it was too late: Piet Mondrian, almost seventy-two years old, died in the Murray Hill Hospital on February 1, 1944.

The facts of this quiet life, devoted to art, have been soon told. The external life of Piet Mondrian was sparse in events, and the few that did play a part were results of the times, of two world wars, which swept over him. But Mondrian's life as an artist, as a painter, was for that very reason all the richer in events, although of a different nature. Here the actions and deeds follow one another like strides along a road, and each canvas is a new accomplishment, a step closer to the goal, on this long straight road.

It is precisely the consistency, the straightforwardness of the road that Mondrian traveled from his early realistic paintings to the rhythmic abstractions of his latest years that is so enthralling. The body of Mondrian's work as it has come to be known through the few large exhibitions held so far, especially the great retrospective survey of 1966, is imposing because of its internal cohesiveness, because of the driving force of a development that emerges from it. And this driving force is none other than the need to go "always further" (to use Mondrian's phrase), further in refining the pictorial idiom, in excising the circumstantial, in striving for the essence and interrelationships of things.

Mondrian began painting at the end of the nineteenth

Die neue Gestaltung. But on the whole the Paris years brought little change. In 1930 Mondrian exhibited with the Cercle et Carré group, led by Michel Seuphor. The next year he joined the Abstraction-Création group that had just been formed by Georges Vantongerloo and Auguste Herbin. In Paris, in 1934, he made the acquaintance of the American artist Harry Holtzman, who became his friend and patron and later helped him to come to the United States. Because of the demolition of the building in rue du Départ, Mondrian was compelled in 1936 to move to 278, Boulevard Raspail.

Two years later, at the time of the Munich crisis, he left Paris and settled in London, at 60 Park Hill Road, Hampstead, where he set up his studio. There he was close to the friends who had received him in England: Ben Nicholson and his wife, Barbara Hepworth, Naum Gabo, Leslie Martin. Mondrian joined the Circle group, in whose publication his article "Plastic Art and Pure Plastic Art" had appeared the year before. In London he kept on working in the style of his Paris days.

But the war, forebodings of which had led him to leave

century, when the art of the Netherlands was dominated by the realism of the Hague school, which in turn was an off-shoot of the French Barbizon school, of which Jean François Millet was the foremost representative. Mondrian's first works bear the imprint of this more or less provincial spirit, a mixture of the realistic and the romantic (see J. H. Weissenbruch's painting *Along the Canal,* figure 18). But even in his early works one is struck by a remarkable trait: the stern rejection of the prevailing preference for romantic effects and attractive-looking details. The young Mondrian was already seeking to express a mood, in a painting conceived as a totality. And the tautness, the broadly seen unity, at a time when most of his contemporaries in the Netherlands were content with effects and details, became all the more significant during his academic years. As the Italian art historian Carlo Ragghianti has pointed out, Mondrian's emphasis on composition may have been due in part to his training, but it was even more an innate necessity to him and hence a personal choice. The early works are striking in their structural severity and rigorous control; despite all their

conventionality, the specific, personal, essential quality is clearly there. A painting like the *House on the Gein* (page 53), done in 1900, exhibits these characteristics quite distinctly. The admiration that the young painter felt for George Hendrik Breitner, the leader of the "Amsterdam impressionists," never led him into following Breitner's most prominent trait: passionate spontaneity.

This period of Mondrian's gradual development within the framework of Dutch art extends to 1907. Influences of symbolism, of metaphorical figuration, had appeared in his early work, but certainly no more so than in that of other contemporaries in the Netherlands. The *Red Cloud* of 1907 (page 59), still deriving from the atmospheric tonality of the Hague school, constitutes a terminal point for this period; the *Woods near Oele* of 1908 (page 61) denotes the transition to a new direction, in which line and color receive greater stress. In the *Woods near Oele,* the rhythm of the lines and the gamut of color, attuned to purple, orange, yellow, and blue, are reminiscent of the work of Edvard Munch as well as of other trends of the time, particularly

14
Edvard Munch: Portrait of Walther Rathenau/1907
Oil on canvas, 86 5/8 × 43 1/4"
Rasmus Meyers Samlinger, Bergen, Norway (Oslo Kommunes Kunstsamlinger)

15
Claude Monet: The Ducal Palace at Venice/1908(—12?)
Oil on canvas, 32 × 39 1/2"
The Brooklyn Museum, New York

fauvism. And although the *Red Cloud* contains many of the elements that later became prominent in Mondrian's art, it is the *Woods near Oele* that is the significant work of the breakthrough, especially in its compositional texture. Here Mondrian found his point of attachment to international art, and his horizon expanded beyond the narrow paths of his national domain.

This breakthrough, when he was already over thirty-five, was certainly helped along by his contact with his new friends in Domburg, Jan Toorop and Jan Sluijters. The dominant trend of Mondrian's art was now toward Dutch luminism, a synthesis of Vincent van Gogh's expressive color and Georges Seurat's systematic brushwork; this was the artistic idiom of avant-garde Dutch painters in the first decade of the twentieth century. But within the scope of this trend Mondrian's work differs from that of his friends and colleagues, and the difference lies in the very qualities that had determined the character of his work in his earlier period: tautness and breadth of vision. The views of the Zeeland dunes (figures 20 and 21, page 71), the various versions of the lighthouse at Westkapelle (figure 55, pages 63, 69, 73), and the canvases of the church at Domburg (page 75), all exhibit a monumentality that cannot be found in any other Dutch luminist; we see it in the rigorous structure of the forms and in the firm but still radiant color. The breadth of form and impressive unity are not a matter of change of technique. It is Mondrian's vision of nature, his way of seeing, that makes him choose, over and above the wayward forms of nature, a clear and distinct silhouette that complies with very simple laws of composition.

This new development, this expansion of Mondrian's horizon, appears most clearly in two subjects that were favorites of his at the very beginning of his career: windmills and trees. Comparison of the 1908 *Windmill in Sunlight* (page 65) with older paintings of the same subject (page 57) shows not only simplification and purification of the colors to red, yellow, and blue, but also a robust, determined formal structure: the use of a grid of horizontal and vertical brush strokes, especially in the central portion. If in turn we compare this 1908 painting with the 1911 *Red Mill* (page 77), the direction in which Mondrian was evolving becomes very evident: the later version of the theme is marked by a tautness and monumentality based primarily on reduction of the forms and reinforced by the simple contrast of the colors. It is worth noting how closely related, in formal organization and style, the *Red Mill* is to the *Evolution*

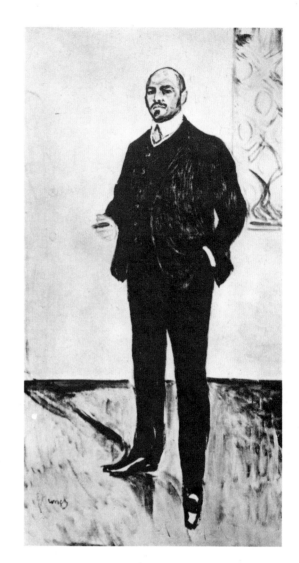

17

16
Jan Toorop: Canal near Middleburg/1907
Oil on cardboard, 12 1/4 × 16 1/8"
Gemeentemuseum, The Hague

17
Jan Sluijters: Dumping Carts/1907
Oil on canvas, 15 3/4 × 23 7/8"
Museum Boymans-Van Beuningen, Rotterdam

18
J. H. Weissenbruch: Along the Canal/c. 1890
Oil on canvas, 23 1/2 × 31 1/2"
Private collection, Netherlands

19
Woods near Oele/1907
Oil on cardboard, 24 3/8 × 28 3/4"
Kunsthandel M. L. de Boer, Amsterdam

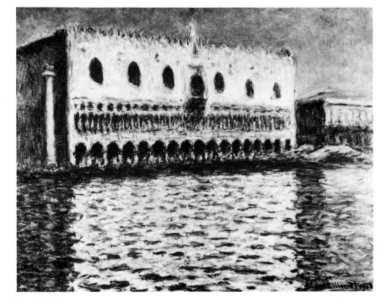

15	**18**
16	
17	**19**

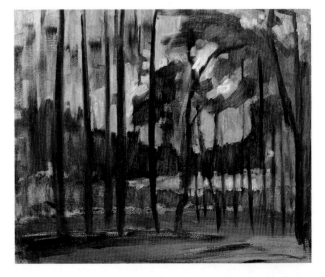

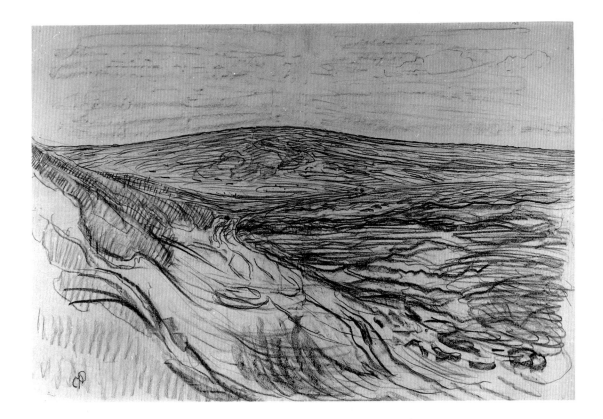

triptych (figure 22) of about 1911, in which theosophical ideas of the unity of man and nature are implicit. The anthropomorphic shape of the red mill itself may also reflect this theosophical ideal, with which Mondrian had expressed his agreement by joining the movement in 1909. The capacity for monumentality that Mondrian evolved in these years comes to the fore with equal strength in his humane and ethical world view and in his aesthetic observations as a painter. It is precisely this fact that characterizes his style in this period and makes him depart from fauvism, whose technical achievements he made use of, but only for a purpose he had determined for himself. What he tries to achieve with the brilliant, arbitrary color and violent touch of fauvism is not an expression of subjective, personal excitement but a superpersonal grandeur which he discovered over and over again in nature and its phenomena.

An excellent example of this monumental quality evoked by nature is Mondrian's *Red Tree* of 1908 (page 67). In this painting, too, the natural color scale is reduced to the contrast of red and blue, symbolically representing a balance between the tragic and the serene. Even more striking, the three-dimensional form of the tree is translated into a completely two-dimensional idiom. Here, by means of simplification of form and color, the monumentality of nature is transformed into the language of painting; or rather, Mondrian has found an adequate language for the grandeur he has seen in nature, the language of pure colors and strict form.

And yet these last works of his luminist period show that he placed greater emphasis on form than on color; the *Red Mill* and similar works are a clear indication of this trend. The transition to cubism, which was the next major step on Mondrian's road to austere simplicity, was thus no externally motivated change of style, but a logical inner development, the fundamentals of which were already present in Mondrian's work and, so to speak, ready for ignition at this very moment. In the autumn of 1911 Mondrian presumably saw cubist paintings for the first time at the Moderne Kunstkring exhibition in Amsterdam. There can be no doubt, however, that he had previously heard

21
Dune II/1909
Oil on canvas, 14 7/8 × 18 3/8"
Gemeentemuseum, The Hague (Collection S. B. Slijper, on loan)

22
Evolution (triptych)/1910/11
Oil on canvas, 70 1/8 × 33 1/2", 72 × 34 1/2", 70 1/8 × 33 1/2"
Gemeentemuseum, The Hague (Collection S. B. Slijper, on loan)

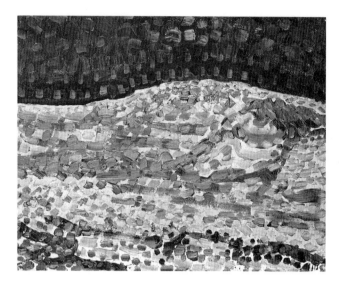

23
Tree I/c. 1909/10
Drawing, black chalk on paper, 12 1/4 × 17 3/8"
Gemeentemuseum, The Hague

24
The Blue Tree/1909/10
Oil on cardboard, 21 7/8 × 29 3/8"
Collection Mr. and Mrs. James H. Clark, Dallas, Texas

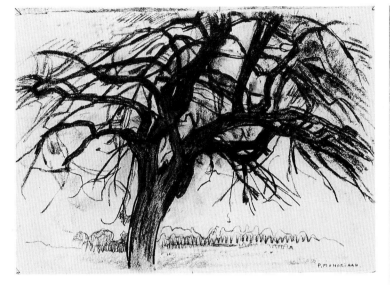

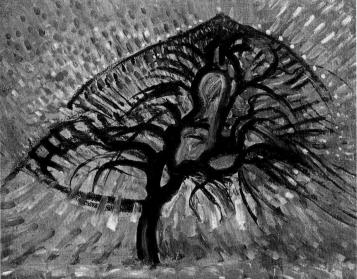

from Conrad Kickert about this new movement in painting and that he had seen reproductions of cubist works. The introduction at second-hand must have intensified the impact of the originals on Mondrian. For years he had sought to liberate his impressions of nature from their capriciousness, from the factor of accident that is inherent in immediate perception. In cubism he suddenly found a language, a grammar, a method with which to subdue and master nature, while still expressing its grandeur. Cubism's strict objectivity, its lucid and classical matter-of-factness satisfied Mondrian's longing. In the new style he must have seen potentialities that had previously been latent in himself: the logical mastery of a simple and rigorous methodology.

In his autobiographical essay of 1942 Mondrian acknowledges that he was strongly influenced by the work of Picasso (figure 26) and Léger. In 1912, soon after his removal to Paris, his paintings began to show the marks of the new trend. Form and structure predominate in these works, even at the expense of color; as in the works of the French cubists, the color scale in Mondrian's pictures is reduced to shades of yellow, ocher, and brown, with a few accents in blue or green. His canvases of this period are cubist abstractions in the precise literal sense in which the word "abstraction" was used at that time: Mondrian reduces the wealth, the diversity of natural forms—trees, church façades, blocks of houses—to a framework of pictorial signs, to the notation of a formula. What he is driving at is a strict allegiance to universal principles: just as the multifariousness of sound can be reduced to the seven tones of the lyre, or the twelve semitones of the chromatic scale, so in the plastic language that he was looking for it should be possible to reduce all diversity to a small number of signs. The evolution of his cubist work clearly reveals the motive force of his credo "always further." Not only is it a question of translating fragments of nature into a rigorously formed language, but this language itself becomes ever purer and more economical. Gradually the curved lines and the obtuse or acute angles disappear from his compositions, and all that is left is a grid of horizontal and vertical lines,

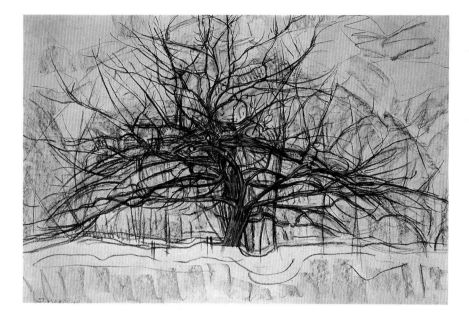

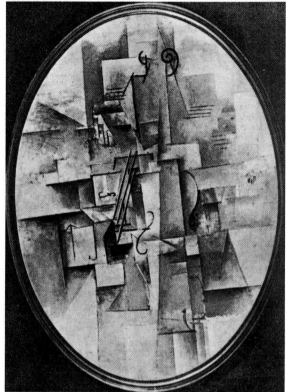

still broken here and there by a few diagonals. Slowly he subdues and simplifies his color spectrum as well; the intermediate tones, such as gray and brown, vanish gradually, and the chord of his mature cubist works is comprised of the triad of light blue, pink, and ocher yellow. Here too, in the long run, form predominates over color; the last works of Mondrian's cubist style, created in the Netherlands after 1914, are almost all without color.

Beautiful and exciting examples of Mondrian's development in the direction of cubism, probably dating from the period just before and just after he moved to Paris, are the two versions of the *Still Life with Gingerpot,* both done in 1912 (pages 79, 81). The first thing to note is that after many years Mondrian once again takes up the theme of the still life—a theme not created by nature but "composed" beforehand by man. In the first version the objects still appear in their matter-of-fact reality—the gingerpot at the center of the composition, the glass, the knife, the tablecloth, and so forth—whereas in the second they are organized and reduced to pictorial signs which, apart from their role as notes

in a plastic symphony, have no more actual life of their own. Moreover, in the second version the placing of the color is subordinated to the compositional unity, which now, quite in the current of cubist work, shows a tendency to assume the form of an oval.

The same tendency is visible in the paintings in which Mondrian took up the theme of the tree once more (pages 83, 85). These works are strict, architectonically constructed compositions of curved lines, in light tints, compositions in which the theme of the tree is only a source of the title, a starting point. The essential aspect is the structure of these works, the methodology employed to control the arbitrariness and randomness of nature; it is the method of analytical cubism, which reduces the forms of objects to facets and reproduces their volume on the pictorial surface by means of superimposed planes.

Mondrian follows the method and idiom of the cubists in his pictures of this first Paris period, but he goes much further in the direction of rigor and simplification than the original masters of cubism ever did. The structure of his

27
Trees on the Gein, with Rising Moon/1907/8
Drawing, charcoal on paper, 24 3/4 × 29 1/2"
Gemeentemuseum, The Hague (Collection S. B. Slijper, on loan)

28
Trees on the Gein/1907/8
Oil on cardboard, 21 1/2 × 29"
Collection Mr. and Mrs. Louis A. Green, New York

29
Trees on the Gein/1908
Oil on canvas, 27 1/8 × 44 1/8"
Hannema-de Stuers Foundation, Heino, Netherlands

30
Landscape with Tree-Lined Road/1905/6
Drawing, charcoal on paper, 18 3/4 × 24 1/2"
Museum of Fine Arts, Boston (William E. Nickerson Fund)

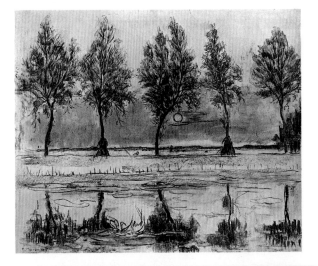

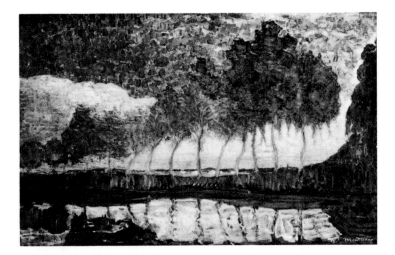

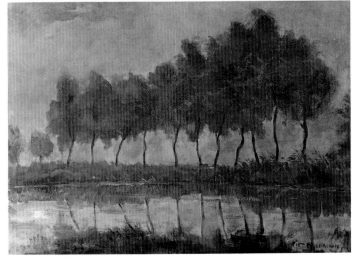

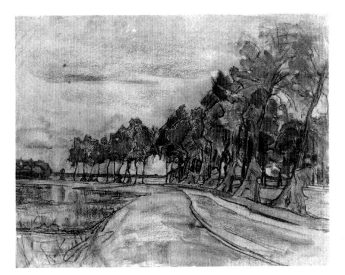

paintings coincides to a great extent with the work of the cubists, by virtue both of the subdued color scheme and of the composition, which is centripetal, so that the density of the forms increases toward the center and the pictures generally take the shape of an oval. The point at which Mondrian goes "always further" is the relationship of his pictorial idiom to the forms of actual phenomena. The role that objects play in his paintings is much less essential than with the cubists. For him the central point is the balance of the composition, the independent validity—quite apart from the subject that was its occasion—of the small world created on the canvas, a world now complete in itself. During his Paris years, Mondrian pushed cubism beyond its boundaries; he did not allow the fascination of things to divert him from the mathematically strict, eminently spiritual method that cubism had put into his hands. On the contrary, he was able to add his own impulse toward abstraction—toward stripping the form from the object— and so to make cubism the starting point for further development. Although this development did not lie within the aims of cubism, it did coincide with another current in the visual arts that was just then beginning to stir.

The last phase of Mondrian's cubist period, when he carried cubism further than any other cubist, thus took place not in Paris but in the Netherlands. Mondrian had gone there to visit his sick father in the summer of 1914, and the outbreak of the war made it impossible for him to return to Paris. In the Netherlands, at Scheveningen and Domburg, and later at Laren, the great compositions were created that drew their inspiration from the theme of Pier and Ocean (page 91). There are drawings (figures 34, 35, 36) that document the starting point of this subject: the pier built straight out into the sea, where the waves come in against the coast. This theme, or rather the rhythm of the waves and the contrary thrust of the breakwater, is the foundation of a series of sketches and paintings dating from 1914 to 1917. All these works have a strictly cubist compositional scheme: they are almost monochrome, that is, the emphasis is completely on form; and they show the cubist centripetal composition, that is, they have in common an oval shape, the corners of the canvas remaining almost unworked. The further elaboration, however, is characteristic of Mondrian's own development: the form of the pier, the wash of the waves and the breakers, all the forms of nature, are translated into a rhythm of short vertical and horizontal line fragments sometimes intersecting to form crosses. In the early canvases on this theme, some correspondence with the first sketches

32
Oval Composition with Trees/1913
Drawing, charcoal on paper, 33 1/2 × 27 5/8"
Gemeentemuseum, The Hague (Collection S. B. Slijper, on loan)

33
Composition with Trees/c. 1912
Oil on canvas, 38 5/8 × 25 5/8"
Gemeentemuseum, The Hague (Collection S. B. Slijper, on loan)

34
Pier and Ocean/1914
Drawing, charcoal and India ink, 21 7/8 × 26"
Collection Harry Holtzman, Lyme, Connecticut

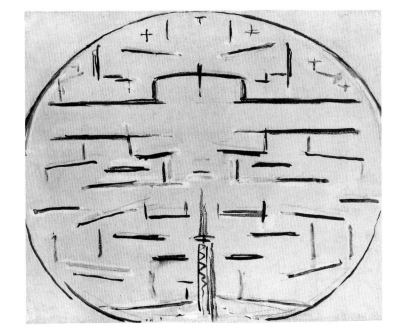

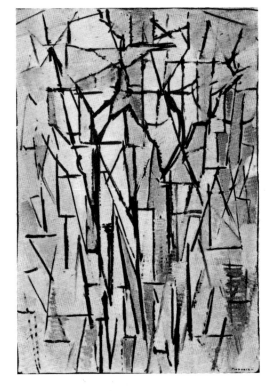

is still evident; in the later versions, especially in the painting of 1917 (page 95), Mondrian departs so far from his starting point that virtually nothing remains to recall it. Here too he has gone "always further." In his quest for "a true vision of reality," for the essential, he has liberated his impressions from everything fortuitous to such an extent that only a general memory of the grandeur of nature remains. This grandeur was his concern, the reason why he went so far with his generalization and simplification, by means of which he had now attained a provisional climax in his work. It was, at the same time, an end point, since the cubist road did not lead any further.

The change that took place in Mondrian's art shortly thereafter, in 1917, was not the direct outcome of his work in the preceding phase, but rather the result of the artist's constant search for still greater simplicity, still more convincing generality, for what he repeatedly calls, in his later essays, "a true vision of reality." His contacts in Laren with Bart van der Leck and Theo van Doesburg, and, more incidentally, with the philosopher of Laren, Dr. M. H. J.

35
Pier and Ocean/1914
Drawing, charcoal on paper, 20 1/8 × 24 3/4"
Gemeentemuseum, The Hague (Collection S. B. Slijper, on loan)

36
Pier and Ocean/1914
Drawing, colored crayon and gouache, 34 1/8 × 44 1/8"
The Museum of Modern Art, New York (Guggenheim Fund)

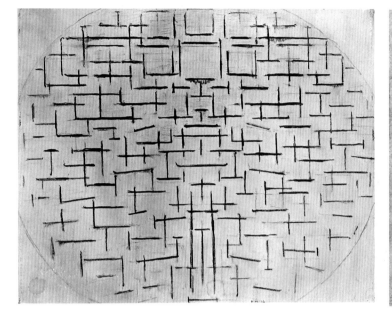

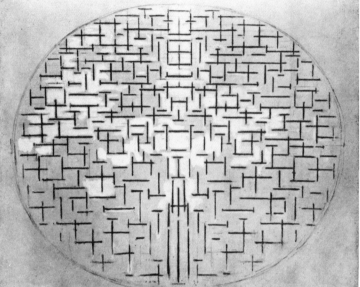

Schoenmaekers, played an undoubted part in this new orientation. Mondrian himself, in his essay in the 1932 issue of *De Stijl* commemorating van Doesburg, who had died the year before, admitted that the geometrically structured style of van der Leck's paintings in primary colors had helped him on his own way, a way that he shared for a while with others. The four painters of the Stijl group founded in 1917—Piet Mondrian, Bart van der Leck, Theo van Doesburg, and Vilmos Huszar—worked for a short time in a single style, which was just as much a collective idiom as was cubist composition during the first years of that movement. It is as hard to distinguish the works of Mondrian, van der Leck, and van Doesburg in the years from 1917 to 1919 (figures 39, 42 and page 97) as to discriminate among the works of Picasso and Braque in what are called the "heroic years" of cubism, from 1908 to 1912.

The pictorial language characteristic of De Stijl, and to whose development Mondrian made so important a contribution, may be described as follows: It is based on total abstraction, that is, it does not concede any connection whatever between the perception of fortuitous fragments of reality and artistic creation. In connection with this abstraction, it confines itself to the elements of painting: the straight line and the right angle (that is, the horizontal and the vertical line), the three primary colors (red, yellow, and blue), and the three primary non-colors (white, gray, and black). With this extremely limited arsenal of pictorial means, the painters of De Stijl aimed at presenting "the true vision of reality": an image of reality that should be independent of the accidents of momentary perception and likewise of the arbitrariness of the individual temperament of the artist. The objectivity that Mondrian had sought for so long seemed now to be within reach.

The new style, for which Mondrian coined the name neo-plasticism, was not the work of a single man. Mondrian made his own contribution to it by approaching the limits of total abstraction in his cubist-based works of the years between 1914 and 1917. Van der Leck's contribution, as Mondrian himself pointed out, was a geometrical architecture of forms linked with the use of primary colors; but van

37
Bart van der Leck: The Storm/1916
Oil on canvas, 46 1/2 × 62 5/8"
Kröller-Müller State Museum, Otterlo

der Leck always started from an object, although his geometrical stylizing made it all but unrecognizable (figures 38, 39). Theo van Doesburg, founder of the periodical *De Stijl* and its editor throughout its existence, as well as the spiritual activator of the group that formed around the magazine, brought to the common enterprise a direct connection with architecture and solid experience in painting and criticism. And outside the group of artists Dr. Schoenmaekers worked as a catalyst does in a chemical reaction, a substance that is not changed in the reaction yet brings it about. Schoenmaekers' books, in which he developed a "positive mysticism," showed the painters of De Stijl, and Mondrian in particular, the way to discernment of a universal force and the possibility of making it visible as a pictorial harmony.

Mondrian's new way of painting did not appear all at once. The intermediate stages between the previous phase and neo-plasticism are exciting and highly important for the evolution of the new style. In 1916 the large *Composition* of that year (page 93) showed a reorientation toward the primary colors. In 1917, after various transitional works, compositions with areas of color appear (page 97), embodying the principles of the new style for the first time. In contrast with the work of 1916 and the large *Composition with Lines* of 1917 (page 95), which were essentially still cubist and linked to an object, these pictures have an entirely different principle as their starting point. Their composition is based on color and is centrifugal, that is, it does not draw together into foci but spreads out, radiating even beyond the edges of the canvas and filling the space with a rhythm that goes out of the painting rather than remaining confined to its surface. This was a break, a transition, that was to remain dominant in Mondrian's further work.

The new, colorful, and expansive style came in part from Mondrian's development as a painter and in part from his thinking and the reflections that he published in *De Stijl* magazine in 1917, at Theo van Doesburg's urging. And his thinking accounts for the most important advance in his new style: total abstraction. From 1917 on Mondrian no longer began with an accidental fragment of nature, which he then

38
Bart van der Leck: Donkey Riders/1915
Casein on eternite, 12 1/2 × 22 1/2"
Kröller-Müller State Museum, Otterlo

39
Bart van der Leck: Abstract Version of "Donkey Riders" (Composition 6)/1917
Oil on canvas, 23 1/4 × 57 7/8"
Collection Mrs. A. R. W. Nieuwenhuizen Segaar-Aarse, The Hague

40
Theo van Doesburg: Card Players/1916/17
Tempera, 46 1/2 × 58"
Collection Mrs. N. van Doesburg, Meudon, France

41
Theo van Doesburg: Abstract Version of "Card Players" (Composition 9)/1917
Oil on canvas, 45 5/8 × 41 3/4"
Gemeentemuseum, The Hague

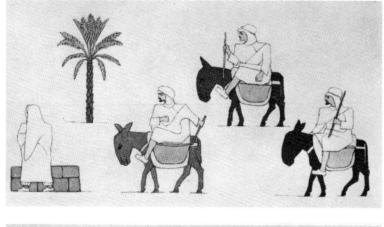

brought into virtually perfect equilibrium by rigor and generalization. He now started from the principle that the absolute harmony he sought could be constructed only by means that were abstract, and hence generally valid and objective, so that they could no longer be derived (abstracted) from a fortuitously existing thing. The origin of the Stijl phase in Mondrian's art shows some points in common with the origin of synthetic cubism out of analytic cubism: there too the artist starts with the means in order to achieve his intended result. It is a serious misunderstanding of Mondrian's work and of the situation in 1917 to suggest, as some authors do, that the new composition was inspired by any such naturalistic model as the Dutch tulip fields or Japanese architecture. Mondrian nowhere expresses interest in the tulip fields, and I have been reliably informed by persons close to the Stijl group that there was no talk of Japanese architecture in 1917. A decade later, looking back at the beginnings of the new art, Mondrian wrote: "Neoplastic painting arrived, by way of abstracting the natural course of things and not by copying architecture, at likewise

expressing the cosmic equilibrium." Indeed, Mondrian's entire development up to 1917 advances so consistently and straightforwardly to its goal of ever-decreasing material representation of harmony that a naturalistic "crutch" would be totally out of place. Such a hypothesis moreover implies that Mondrian deliberately avoided mentioning the source of his new style (and of De Stijl). In fact, he always stressed frankness and honesty as the basis of artistic development and never claimed to have originated the new method of composition, but courteously indicated Bart van der Leck's experiments with a mural style as a primary source of inspiration. These factors together constitute the pictorial starting point of the mutation in Mondrian's style. Other, and probably more important motives are to be found in the domain of philosophy, including the contact with Dr. Schoenmaekers, and in Mondrian's urge to go "always further" on his way to purity, universality, and simplicity.

The foundation for this new style was laid down in 1917, at the time of the founding of *De Stijl* magazine. During the

43

Bart van der Leck: Geometrical Composition No. 2/1917
Oil on canvas, 37 x 39 3/8"
Kröller-Müller State Museum, Otterlo

44

Vilmos Huszar: Design on jacket of De Stijl/*1917–20*

next few years Mondrian developed the principles of the new composition into a complete mastery of all his means. In some works he experimented with color and in others with linear structure, until, beginning with a remarkable 1918 painting (page 99), he succeeded in welding line and color into a balanced whole. From that time on, with his mastering of the new idiom, he felt that he was able to render the harmony that he had always sought, without any subjective arbitrariness and without any fortuitous natural data. Mondrian achieved this mastery in a series of works (pages 105, 107, 109) created between 1920 and 1922. In the meantime, in 1919, he had returned to Paris. There, in 1920, he stated the principles of the new style in his brochure *Le Néo-Plasticisme.* Likewise in Paris, from this time on, he created his neo-plastic masterpieces, undisturbed by external events, isolated in his lonely, modest, and often poverty-stricken existence. These works are compositions of horizontal and vertical lines and primary colors, models (in the literal sense) of complete harmony.

Mondrian spent all the years of his sojourn in Paris from 1919 to 1938 in perfecting this style. Every painting he finished became the starting point for the next one, which had to be a step forward. His pictures constantly grew purer and more radiant; the harmony he expressed in them became ever simpler and more powerful. In 1925 Mondrian's lozenge-shaped paintings appeared (page 111) in answer to van Doesburg's attempt to employ the diagonal (figure 48). In the same year, because of van Doesburg's "deviation" from the principles of De Stijl, Mondrian left the group, but remained faithful to his own style. In some canvases of the thirties he limited his design to a few black or yellow lines of varying breadth and length on a white background (figure 50, page 115); after 1935 the linear structure is dominant, and only a small area of primary color appears amidst an assemblage of black verticals and horizontals (page 117). The possibilities of neo-plasticism are endless, but all these works are pervaded by a stern, noble harmony, solemn and yet lively, as in old psalms or plainsong.

The trend of the last Paris paintings is continued in the works of Mondrian's London period, although not much has

45
Lozenge with Gray Lines/1918
Oil on canvas, 47 1/4" diagonal
Gemeentemuseum, The Hague

46
Lozenge with Gray Lines/1919
Oil on canvas, 47 1/4" diagonal
Philadelphia Museum of Art (Arensberg Collection)

come down to us from these two years, principally because the artist finished or altered many of his London pictures in New York (page 121). But the harmony of these works seems to be set in a minor key. The menace of the second world war, which was drawing nearer and nearer, seems to cast a shadow on these canvases, as it does on the last Paris works. The brilliant chords of the Paris pictures of the twenties seem to have disappeared; the viewer feels a certain oppression, a harmony in the minor mode, in the rhythm of the black lines that dominate the paintings from the late thirties and early forties.

It was not until Mondrian reached America in 1940, in his sixty-eighth year, that his art once more underwent a renewal. There the last and perhaps the most brilliant works of this painting-filled life were created; there too, especially in a last trio of compositions (pages 123–127), the road, the long straight road, of Mondrian's art came to an end. Each of these last works poses new compositional problems and solves them. Sometimes we are reminded of the works of 1917, at the beginning of the Stijl period; sometimes the

sense of recall goes further back, to cubist works dating from 1914. In the late works in New York, the black lines are replaced by colored bands or by a rhythmic sequence of little blocks of color; the calm, contained rhythm of the Paris canvases goes gradually over into rapid staccato flashes, into a powerful, dynamic movement. Mondrian's creative powers were renewed and inspired by the invigorating impact of metropolitan New York, by the quick rhythms of the new dances, and above all by the certainty of victory over tyranny. But before he could complete his masterpiece in the new manner, *Victory Boogie-Woogie* (page 127), a sparkling, twinkling dance of colors, Mondrian died in New York, five weeks before his seventy-second birthday.

Mondrian's work, as here reviewed in forty-two black-and-white reproductions and forty colorplates, is the product of a long rich life devoted to seeking and eventually finding, a life that proceeds along a rectilinear path, without hesitation or deviation, from the first timid efforts to the radiant last works. The straightness of Mondrian's path, his

47
Composition with Red/1939
Oil on canvas, 41 × 40 1/4"
Peggy Guggenheim Foundation, Venice

48
Theo van Doesburg: Counter-Composition of Dissonants XVI/1925
Oil on canvas, 39 3/8 × 70 7/8"
Gemeentemuseum, The Hague

49
Composition in Gray/1919
Oil on canvas, 37 5/8 × 24"
Marlborough-Gerson Gallery, New York

50
Composition No. 2 with Black Lines/1930
Oil on canvas, 19 5/8 × 20 1/8"
Stedelijk Van Abbemuseum, Eindhoven

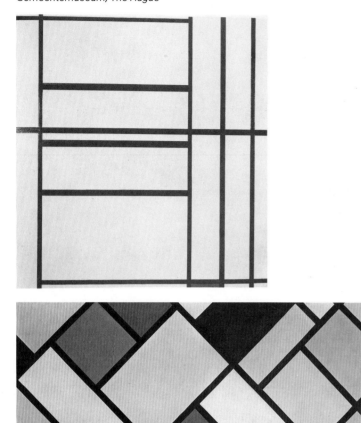

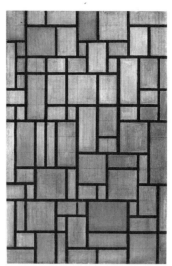

constant seeking of a goal that he saw but dimly at the beginning, his working by the credo "always further," mark him as man and artist perhaps as much as the ultimate result of the work he created. In his case, a survey adds a new dimension to his work, which is merely to say that the significance of his art is not exhausted by an aesthetic evaluation of it.

As compared with paintings by other Dutch painters of the nineteenth century, Mondrian's first landscapes (pages 51–57), however conventional they may be in structure and design, still show a characteristic quest for simplicity and rigor, for strict and universally valid forms. And the same striving occurs again and again in the works that may be regarded as milestones along Mondrian's way: the *Woods near Oele* (page 61), which ends his limited Netherlands period and opens up a prospect on a wider horizon; the various versions of the windmill theme (pages 57, 65, 77) or the solitary tree (pages 67, 83, 85); the series of paintings of the lighthouse at Westkapelle (pages 63, 69, 73), composed with a frontal monumentality and simple,

austere structure; the two versions of the *Still Life with Gingerpot* (pages 79, 81); some of his subsequent cubist compositions, such as the large 1914 oval with three contained colors, or the calm, majestic paintings in black and white based on the theme of Pier and Ocean (pages 91, 95) and known as plus-and-minus-sign compositions (with crossed horizontals and verticals and some horizontals); and finally, the entire series of his neo-plastic compositions (pages 99–121), every one of which is a veritable milestone on his road to greater simplicity and clarity, culminating in the American paintings and finally in *Victory Boogie-Woogie,* the unfinished masterpiece of his last period.

Mondrian's road in painting, from his first works in the manner of the Hague school down to the last, unuttered word of a new and radiant harmony, was always his own road, which he traveled without hesitation in a straight line, imperturbable and patient, even amidst loneliness, lack of comprehension, and poverty. Mondrian never deviated or compromised, not even for his bread and butter, for he

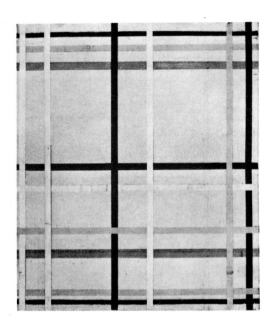

figure that extends far beyond the boundaries of painting. Mondrian stands before us as a sage, a prophet, a pioneer of mankind.

During Mondrian's lifetime his work, like that of his comrades-in-arms of De Stijl, was isolated and uncomprehended, utterly alone. Apart from a small group of friends, admirers, and initiates, there was no one who listened to the prophet, not in his own country and not abroad. Mondrian had always said that art, and in particular the art of De Stijl, went ahead of life; he was to find from experience that very few of his contemporaries were able to bridge the gap between the present and the future.

But far as Mondrian and his Stijl colleagues may have been in advance of their time (and there is no artistic group to which the designation "avant-garde" applies better than to De Stijl), their art, and his in particular, had its origin in the life and artistic evolution of their own day. Mondrian's entire road—from the rather provincial trend of the Dutch realists, via the luminist and cubist periods, to the utmost purity and abstraction that he attained in neo-plasticism—is in the direction of twentieth-century efforts and aspirations: to liberate art from the domination of sensory perception, from the accidental and arbitrary. And it was indubitably Mondrian who traveled this road in the most consistent and straightforward way.

The Stijl group had a term to designate the specific spirit of their age, a spirit to which Mondrian and his friends always attached great importance and in which their art was consciously rooted. That term, which keeps recurring in the writings, was "the general consciousness of time." In the earliest of several De Stijl manifestoes, published in the November 1918 issue and signed by nearly all the members, including Mondrian, this term is emphasized for the first time: "There is an old and a new consciousness of time. The old is connected with the individual. The new is connected with the universal. The struggle of the individual against the universal is revealing itself in the world war as well as in the art of the present day" (*De Stijl*, II, 4).

Mondrian and his friends of De Stijl always regarded the striving for generalization, for a suprapersonal culture, as a characteristic of their age. They found confirmation of this view in many facts. One such was technology, which had brought about a precision that the human hand cannot match. For that matter, the values of precision, calculation, and organization had obviously been advanced in turn by the evolution of society. Twentieth-century division of labor, with its sharp distinction between design and execution, had

regarded his work, his quest for harmony, as a task that he had to fulfill. He never made concessions to the taste of a public that was unable to go along with him on his road to distant objectives. When, in order to keep himself alive, he made watercolors of flowers, often of a single rose or chrysanthemum, which he could sell for a few dollars, he always kept this sort of work strictly separate from what he regarded as his "own" work—the quest for a "true vision of reality."

Searching for that, and finally finding it, filled Mondrian's whole life. And the search was always conducted by means of painting. Mondrian never failed to emphasize that. He had subordinated his entire life to that goal, and his quiet, modest existence was nothing but a service in this task, this commitment. His life passed quietly, without shocks, in devotion to his work. Mondrian's tenacity in going his lonely way, his steady unwavering march, distinguish him as a great figure in the realm of art. The way that he went characterizes him just as much as the goal in front of him, which he attained; the way and the work are part of his nature. He emerges as a

52
Study for Victory Boogie-Woogie/1943
Drawing, pencil on paper, 19 1/8" diagonal
Sidney Janis Gallery, New York

53
Study I for Broadway Boogie-Woogie/1942
Drawing, charcoal on paper, 8 7/8 × 8 7/8"
Collection Mr. and Mrs. Arnold Newman, New York

54
Study II for Broadway Boogie-Woogie/1942
Drawing, charcoal on paper, 8 7/8 × 8 7/8"
Collection Mr. and Mrs. Arnold Newman, New York

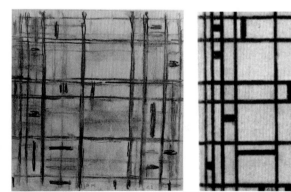

made the significance and importance of abstraction clear to the man of this century. Especially in architecture (and Mondrian worked in De Stijl with a number of architects) the value of abstract thinking was evident: the future building is already present to the mind and spirit in the architectural design (the blueprint), just as a piece of music is already present in the score before it has ever been performed. Science, too, had helped awaken modern man to the value of abstract language; scientific formulas had almost a magical influence on the new consciousness of time.

Mondrian perceived all these factors as working together to produce the "abstract life" that he regarded as characteristic of his age and as a suitable inspiration for his art: "The cultivated man of today is gradually turning away from natural things, and his life is becoming more and more abstract" (*De Stijl*, I, 2). He saw symptoms of this change (which he regarded as a victory of the orderly and universal over the accidental and subjective) in many facts of life: "The machine is increasingly replacing natural forces. In fashion we see a typical tightening of form and an inter-

55
Lighthouse at Westkapelle/1909
Drawing, India ink, black chalk, and gouache on paper, 11 3/4 × 9 3/4"
Gemeentemuseum, The Hague (Collection S. B. Slijper, on loan)

56
Chrysanthemum/1901
Watercolor on paper, 15 1/8 × 7 5/8"
By courtesy of H. M. Queen Juliana of the Netherlands

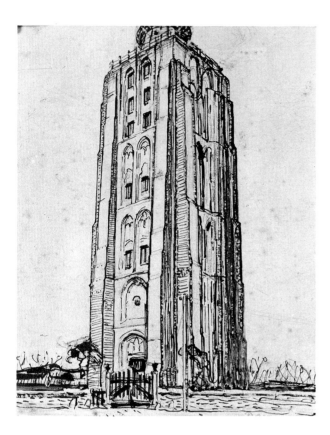

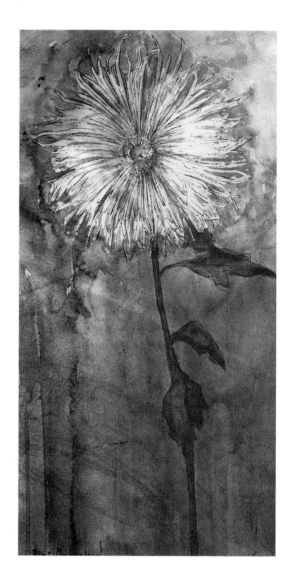

iorization of color, both of which are signs of a withdrawal from nature. In the modern dance (step, boston, tango, etc.) we see the same tightening: the round line of the old dances (waltz, etc.) has given way to the straight line, while every movement is immediately neutralized by a counter-movement—a sign of striving for balance" (*De Stijl,* I, 53).

But the clearest expression of the new era, of the spirit of the twentieth century, is seen by Mondrian as the large city, the metropolis: "The truly modern artist regards the metropolis as an embodiment of abstract life; it is closer to him than nature is, and gives him a greater feeling of beauty. For in the metropolis, nature has already been straightened out and regulated by the human spirit. The proportions and rhythm of planes and lines in architecture will mean more to the artist than the capriciousness of nature. In the metropolis, beauty expresses itself more mathematically; therefore it is the place out of which the mathematically artistic temperament of the future must develop, the place out of which the New Style must emerge" (*De Stijl,* I, 132). And in a later article he writes: "In the reality surrounding us we see the

dominating aspects of the natural vanishing more and more, of necessity. The caprice of rural nature is readily straightened in the metropolis" (*De Stijl,* V, 45). Paris, London, and New York gave birth to the various phases of Mondrian's art, and it is no accident that this art was rejuvenated when he came into contact with the most impressive instance of the metropolis, New York City.

But along with the abstract aspects of modern life there was still another side of the "general consciousness of time" that helped inspire the new art: the fact that the decisive development took place during World War I. It was at that time, in the calm of his summer sojourn in Zeeland and in the as yet unspoiled village of Laren, that Mondrian's ideas came to maturity. World War I had deeply shaken the "old consciousness"; it had shattered the optimism of the nineteenth century and converted the belief in uninterrupted progress into bitter disillusionment. The wonders of technology, admired and esteemed only a short time before, suddenly appeared as frightful instruments of destruction. And the much-vaunted social structure of the early

twentieth century likewise proved to be an illusion: none of the international institutions and societies was able to prevent or shorten the war. An entire generation had lost its feeling of security, of standards; the psychological shock was tremendous, even in the Netherlands, which, as a neutral, escaped the direct effects of the strife. The reaction to the loss of old criteria manifested itself in two ways: in sharp opposition to the past, and in a dream of a utopian future. Both are to be found in Mondrian's work and philosophy. The utopian side came to the fore particularly in the grand picture of the future that he sketches in his writings, the creation of a new, brighter, and cleaner world by means of art. But the other side also occurs in his work. There is the distinct break in 1917, the resolute step into abstraction; and there is also the stress that he lays on the "new consciousness of time," which is to cast out the fatal, tragic domination of individualism, a conviction that led him to dedicate his little book on neo-plasticism to "the men of the future."

Mondrian's thought, universal in dignity and worth, and supratemporal in its rigorous objectivity, has its roots in his own era, in the "new consciousness of time." And in the same way Mondrian's art, which had left the limitations of a national school far behind it, is still based on Dutch characteristics, on qualities that we may speak of, in the words of the Dutch historian Johan Huizinga, as among the "marks of the Netherlands spirit."

First of all, there is Mondrian's most characteristic quality, which forms the motive force of his development: the "always further," the quest for an absolute outcome, for the indivisible elements of art, for a complete and universal vision. This quest has an essentially Puritan, and specifically Dutch, aspect. It originates in the Calvinist, and typically Dutch, sphere in which Mondrian grew up. Nor does this fact in any way subtract from the universality of Mondrian's art or from the supranational validity of his message. Mondrian, the man and the artist, had his roots in the Netherlands, but he far outgrew the boundaries and limitations of his land of origin.

Mondrian was raised in an orthodox Protestant family. His father was principal of a Christian school and a faithful follower and personal acquaintance of the Dutch Reformed theologian and politician Abraham Kuyper. The traces of this background remained with Mondrian all his life. It was precisely the qualities of his upbringing that he sublimated in his art, for the quest for the absolute, the striving for a universal vision, and the total straightforwardness of the thinking involved in the process are all marks of the puritani-

cal Dutch way of life. What Mondrian calls "the true vision of reality" is a concept of the world, of Creation, as an emanation from the Creator—a view of the world that Puritanism inherited from medieval scholasticism: *Universalia sunt realia* (General concepts are real facts). True reality, which the artist pursues for the benefit of all mankind, is corrupted by the capricious, arbitrary forms of nature, and for that reason the artist should eschew these transitory, impermanent phenomenal forms and seek true fundamentals.

In this rejection of the phenomenal forms of nature, which in point of fact is the decisive step of the new abstract art, of neo-plasticism, there is a correspondence, which must be more than a coincidence, with the first manifestations of Calvinism in the Netherlands, the iconoclastic wave of the sixteenth century. And actually Mondrian and his friends of De Stijl were iconoclasts, and were regarded as such in their time; but they were iconoclasts for the same reason as the pioneers of the Reformation in the Netherlands after 1550. To Mondrian, reproduction of the phenomenal form of things was just as much a profanation, a corruption of the

absolute, universal harmony, as, to the sixteenth-century Dutch Reformers, the statues and images of saints were a desecration of God's absolute and invisible majesty. A sentence from Mondrian's writings supports this view: "Precisely on account of its profound love for things, non-figurative art does not aim at rendering them in their particular appearance" (*Circle,* p. 53). These words, echoed in other of his statements, give the direction of the road that Mondrian traveled as an artist.

But there are further consequences of Mondrian's puritanical background. The straightforwardness of his thinking and action is without doubt connected with the orthodoxy of his origins. An aversion to the sensuous attraction of the world (another Puritan trait) can be plainly traced in his road as a painter, and the strict spiritual discipline that characterizes Puritanism is a mark of his work and his character: "That which is regarded as a system is nothing but constant obedience to the laws of pure plastics, to necessity, which art demands from him." This discipline explains, for one thing, the humble, almost religious devotion of Mondrian to his work, and, for another, the sectarian zeal with which he combated any deviation from the correct path, as illustrated by his disagreement with Theo van Doesburg in 1925, which caused Mondrian to leave the Stijl group.

But the most Puritan aspect of Mondrian's work and philosophy is his constant orientation toward an ethical purpose, toward the welfare of mankind. The grand utopia that was given form in his neo-plastic works has many points of contact with the Heavenly Jerusalem; his messianic vision of the future fits perfectly into the Puritan sphere of thinking, with its origin in the Old Testament. In the Puritan tradition of Dutch thought there is one great work that may well be compared with Mondrian's *oeuvre* in this respect: Spinoza's *Ethics.* Given the ethical implications of Mondrian's art and writings, the title of Spinoza's book may be applied to the totality of this work without being unjust to the artist: *Ethica more geometrico demonstrata* (Ethics Demonstrated Geometrically). For it was Mondrian's purpose as well to explain the principles, by means of his work, that should govern life, ethics, mankind. And he chose the "geometrical method" of demonstration in order, like Spinoza, to give his work general, universal validity, in order to attain the extreme objectivity, absolute rightness, that would ensure it against the accidental aspects to which a subjective treatment could lead all too easily. Apart from the fact that Spinoza's *Ethics* was in the library of De Stijl, there

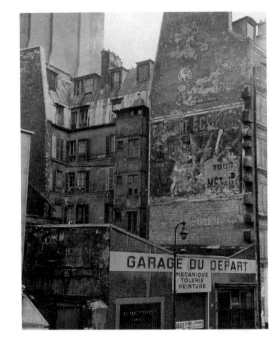

are many other parallels that could be pointed out between the seventeenth-century lens-grinder of Rijnsburg and the twentieth-century painter in Paris. Both worked, with exemplary devotion and consecration, on missions to mankind which did not succeed until after their deaths and which are not yet fully understood, since most people are afraid to go any further than to the artistic or aesthetic balance, the pictorial harmony.

Certainly, this clear, bright harmony is related to the Dutch Puritan tradition; the two meanings of the Dutch word *schoon,* which can mean either pure or beautiful, bring out this spiritual unity. Is it not a fact that the beauty of Mondrian's paintings appears precisely in their purity? And cannot a tradition of purity be made out in Dutch art in which Saenredam, Vermeer, and de Hoogh have their places, and Heda and van der Heyden as well?

Yet this evidence of "marks of the Netherlands spirit" is not the only thing that links Mondrian to the land of his birth. Repeated attempts have been made to derive his work from a view of the flat Dutch polders, or even from a bird's-eye view of the colorful tulip fields. Any such assumption of a naturalistic source for Mondrian's abstract paintings is, in my opinion, a misjudgment of the essence of his work and his innovation. On the other hand, it is true that in Mondrian's early work and in his first dialogues in *De Stijl,* aspects of the Dutch landscape appear that correspond to the character of his work: the Netherlands is one of the few countries in the world where the horizon is not an imaginary line but an optically existing fact, which cannot but affect the eye and vision of a young painter. Mondrian refers to this in one of his *De Stijl* essays: "Repose is so strongly suggested by this landscape because both the horizontal and the vertical are manifested there. The relation of position appears in the natural harmony. Not, however, in pure equilibrium" (*De Stijl,* II, 86—87).

The connection between Mondrian's work and the Dutch landscape, which is often thought of as present on the visual plane, and which I, at least for his neo-plastic work, would reject just as categorically as a similarly asserted link with Japanese architecture, seems to me rather to exist on quite a different plane and in a way that fits much better into the structure of his feeling and thought. That is, the landscape of the Netherlands is not "nature," not Creation, but the work of man. Generation after generation has worked this land and, with the qualities of precision, calculation, and economy that are required, given it its non-natural appearance. Roads, canals, and dikes run in

straight lines and frequently intersect at right angles. For the straight line is the mark of man and his work, in contrast to the curved, moving line that is characteristic of nature, of organic growth.

It seems to me that here, and not in any visual resemblance, lies the connection between Mondrian's paintings and his native landscape. Mondrian's work, and that of his friends of De Stijl, arises out of a proud defiance of nature, a high-spirited desire to be creator in one's own domain and in one's own way. In the forefront of Mondrian's art are precisely those qualities—precision, neatness, feeling for measure and distance—that have acquired special value in the Netherlands by virtue of the long and continual struggle against the water; precisely the qualities that exclude capriciousness, willfulness, the fortuitous. It may be a coincidence, but a significant one, that in the same year of 1917, when neo-plasticism was created, another act of human creation took place in the Netherlands, and one of the most glorious: the beginning of the reclamation of the Zuider Zee. The winning of farmland from nature coincides completely with Mondrian's thinking, with his utopia. And it is certainly no accident that the form of the metropolis he visualizes, in which "the caprice of rural nature is readily straightened," to use his own words, finds its model and stimulus in the structure of the Dutch landscape.

Mondrian traveled the road that led him "always further," from a provincial realism to the embodiment of a strict geometrical abstraction, entirely as a painter. The stages and the milestones along this road are clearly before the eyes of the viewer of his work. But the motive force of this "always further," the message that Mondrian put into his work, went beyond the limits of the art of painting: in the content of his pictures, he poses the problems of art and life, brings up questions that embrace both aesthetics and ethics.

From the outset Mondrian's work tended toward abstraction, and after 1917 became completely abstract, that is, without any reference to an object selected from the world of perception. From this fact the mistaken conclusion is all too often drawn that his mature paintings have no content. Just like a musical composition, and equally independent of perceptual nature, Mondrian's work interprets an essential content, and rendering that content visible is what the artist is concerned with. Mondrian is engaged in depicting the universal harmony, the laws that govern our universe. These forces are only partially visible in perceptible nature; the artist's intuition can discern them in their purity and reveal

61
Church Facade/1913/14
Drawing, chalk and pencil on paper, 6 1/8 × 9 3/8"
Collection Mrs. Phyllis Lambert, Chicago

62
Notre Dame des Champs, Paris

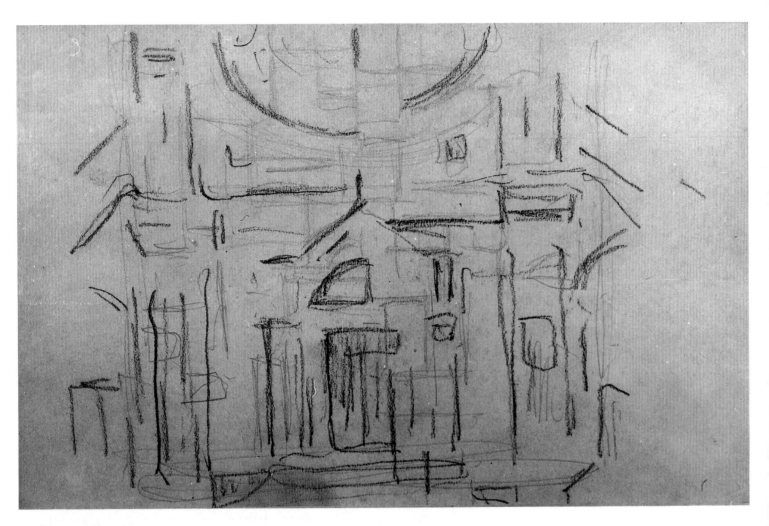

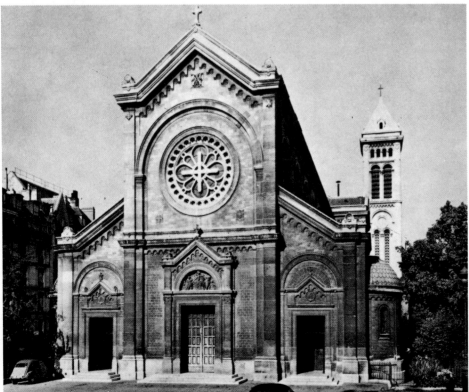

63
Composition in Color B *(verso)*/1917
Black ink on canvas, 19 5/8 × 17 3/8"
Stedelijk Van Abbemuseum, Eindhoven
(on loan from Kröller-Müller State Museum, Otterlo)

them to others. For the depiction of this universal content, only abstract pictorial means can be used: "If indeed the appropriate elaboration of the expressive means and their use—that is, composition—is the only pure expression of art, then the means of expression are to be in complete conformity with what they have to express. If they are to be the direct expression of the universal, they cannot be other than universal, that is to say, abstract" (*De Stijl*, I, 5).

This extreme simplification, this search for the most general, evolved slowly in Mondrian. We see his conception of nature liberate itself gradually from the arbitrariness of a given theme (which can never be more than a fragment of the entire reality) and the capricious impulses of the artist, which too often menace the generality of his artistic intention. In the first half of his work, up to 1917, he remained always bound to a motif—a tree, a windmill, a church façade—although he tried to free it from fortuitous aspects; as a result, all the early paintings are bounded, centripetal, up to and including his cubist works. It was only after 1917, after the turning point in his work, that the rhythm of his art escapes from all boundaries; the rhythm of universal harmony knows no limits, is never confined to a little canvas; it radiates out from the canvas over the wall, into space, always further.

Mondrian created neo-plasticism as a painter; step by step he went along the way to a pictorial rendering of this world view. But this new world view was not limited to painting. Mondrian's familiarity with the wisdom of the East, his interest in theosophy, and his membership, from 1909 on, in the Netherlands Theosophical Society, helped him to attain the new vision, as did the works of the Laren philosopher, Dr. Schoenmaekers, with whom he was in close contact during his Laren period. Schoenmaekers' ideas, especially his conception of an active universal force, had undisputed influence on Mondrian's way of thinking, but the artist's great achievement was to make these ideas, with their ethical and aesthetic implications, visible images. His art, which always aimed at being "a true vision of reality," wrestled with the problem of objectivity from the very beginning and finally arrived at a solution of it: "We come to see that the principal problem in plastic art is not to avoid the representation of objects, but to be as objective as possible."

The vision that Mondrian formulates here and elsewhere in his writings, and that he embodied magnificently in his paintings, is in fact related to Plato's doctrine of ideas. His entire evolution as a painter aimed at visually interpreting the

general laws that underlie every phenomenon and that are to the wealth of natural forms as a theme is to its variations. A quotation from Plotinus cited in *De Stijl* sums up this vision concisely: "Art is above nature, because it expresses ideas of which the objects of nature are the defective likeness. The artist, relying only on his own resources, rises above capricious reality toward reason, by which, and according to which, nature itself also creates" (*De Stijl*, I, 48).

Mondrian and his friends of De Stijl assigned a new function to art. It no longer aims at holding fast, preserving, the transitory appearance of reality; it must give visual form to a new world view: "Art, although an end in itself, is, like religion, a means by which the universal may be revealed, that is to say, plastically contemplated" (*De Stijl*, I, 52).

Contemplation of the universal, and hence penetration into the core of reality, is the meaning that Mondrian gives his art. In one of his essays in *De Stijl* he defends the abstract means of language with precisely this argument: "If it is one's intention to manifest what things have in common and not what makes them differ, this is not a drawback, but a necessity. For the particular, which leads us away from the principal, is abolished by this procedure; the common factor remains. The expression of things gives way to the pure expression of relation" (*De Stijl*, II, 39).

These words may be used to describe Mondrian's entire evolution: "The expression of things gives way to the pure expression of relation." But this art, this new equilibrium, has a significance for Mondrian that goes much further and deeper: "The clarification of equilibrium through plastic art is of great importance for humanity. It reveals that although human life in time is doomed to disequilibrium, notwithstanding this, it is based on equilibrium. It demonstrates that equilibrium can become more and more living in us. Reality appears tragic to us only because of the disequilibrium and confusion of its appearances." By attaining this equilibrium, painting takes on new significance; it now has the function of placing the universal harmony before the eyes of man, as an example to follow. For the first time painting has mastered a new world view: "Thus painting could realize in artistic expression what the new consciousness of time is still busy realizing in external life" (*De Stijl*, I, 127).

On this concept Mondrian erects his great and touching utopia, a vision of the future based not on political or social tenets but on aesthetic experience. It was in keeping that he should dedicate his programmatic essay *Le Néo-Plasticisme*,

the credo of the new style, "Aux hommes futurs"—to the men of the future, for whom art should prepare the way. And the first conquest that this new world view should make is the creation of the New Life, the liberation of man from tragedy, "But we can escape the tragical oppression through a clear vision of true reality, which exists, but which is veiled. If we cannot free ourselves, we can free our vision." The idea is stated even more clearly in an early writing: "Tragedy is abolished only by the creation of (final) unity; in external life this is far less possible than in abstract life. In art the unity of the one and the other can be realized abstractly: therefore art is ahead of life" (*De Stijl*, I,105). The practical conclusion is surely obvious: "Now, since the abolition of the tragic is the aim of life, it is illogical to oppose Neo-Plasticism" (*De Stijl*, I, 107). Hence, neo-plastic painting is not only the forerunner of a new art but also presages a new way of life, which is to realize the laws of universal harmony and bring man into consonance with the universe.

Mondrian had realized the tragedy of life very early, for despite his seclusion his sensitive nature was keenly aware of all the injustice and oppression that he saw around him. For him, this tragedy had two main causes: the predominance of human subjectivity, of individualism, and the resulting disequilibrium of our social system because of a lack of spirituality. But at just this point lies the task of art: "The pure plastic vision should set up a new society just as in art it set forth a new plasticism. This will be a society based on the equation of the material and the spiritual, a society composed of balanced relationships" (*De Stijl*, II, 137). Here we can see Mondrian's utopia in all its significance: an aesthetic utopia, and perhaps thereby characteristic of the Netherlands, its country of origin, where the image rather than the word has always been the means of expression.

With this conception of art, Mondrian and his comrades of the Stijl movement undertook a task that pre-eminently deserves to be called "avant-garde," in the van not only of art but of culture, of human life. "Art is ahead of life: that which we are able to detect in present life is but the prelude of New Life. Therefore let us observe the course of human culture in the free domain of art, to wit: its progressing toward the real liberation from any forms and toward the equivalence of their mutual relationships—toward a life of true equilibrium." Thus art itself can become the avant-garde for life and serve as a beacon for life; thus it can "enlighten" humanity.

Enlightenment: that is the core of the task that Mondrian

64
Church Tower at Domburg/1909
Drawing, India ink on paper, 16 3/8 × 11"
Gemeentemuseum, The Hague (Collection S.B. Slijper, on loan)

and his friends assigned art. And the light of this art falls on many domains, and especially on the domain of life in society. It is thrilling and moving to see how Mondrian develops his utopia, how he adapts it to reality: the equilibrium of the various states is derived from the equilibrium of the areas in a painting—a utopian vision, yes, but despite its idealistic high pitch one of great prophetic power. In this way the function of art, and of neo-plasticism in particular, is lucidly described. Painting becomes an analogue of future reality, a model in the most literal sense of the word. And this exemplary character of art with respect to life is transformed by Mondrian into the axiom, "A feeling for beauty freed from matter could regenerate this materialist society" (*De Stijl*, III, 44).

But it is by no means a vague and shadowy picture of the New Life that Mondrian has; many of its aspects appear to him in clear, sharp outline. And to Mondrian, whose thinking is so outstandingly visual, this image takes on distinctive plastic traits: "The application of these laws will abolish the tragic outlook of the home, the street, the city. Joy, moral and physical joy, the joy of health, will spread by the oppositions of relation, of measure and color, of matter and space, which are to be emphasized by the relations of position. With a little good will, it will not be so impossible to create an earthly paradise."

This earthly paradise was the ultimate aim of De Stijl, of Mondrian: with the other artists who belonged to the group he formed the avant-garde that was to prepare the way for this utopian goal. And once it was achieved, their art would have performed its task, have done its duty, and could depart: "Art will remain a manifestation and a means until this equilibrium is—relatively—attained. It will have done its work, and harmony will realize itself in exterior surroundings as well as exterior life. The domination of the tragical in life will have come to an end" (*De Stijl*, V, 43). This is indeed the task of the vanguard: once they have reached their goal, their work is done, and it is for the multitude behind them, their followers, to take possession. "The time will come when we will be able to dispense with all the arts as we know them today; then ripened beauty will be tangible reality. And humanity will lose nothing by this" (*De Stijl*, III, 66). The earnest certainty and calm with which Mondrian speaks of this future make his utopia seem closely related to the Heavenly Jerusalem, and the theological, eschatological implications point to parallels with St. Augustine's City of God.

And yet Mondrian and the other masters of De Stijl, who

65
Church Façade/1914
Drawing, charcoal, 31 1/2 × 18 3/4"
Collection Harry Holtzman, Lyme, Connecticut

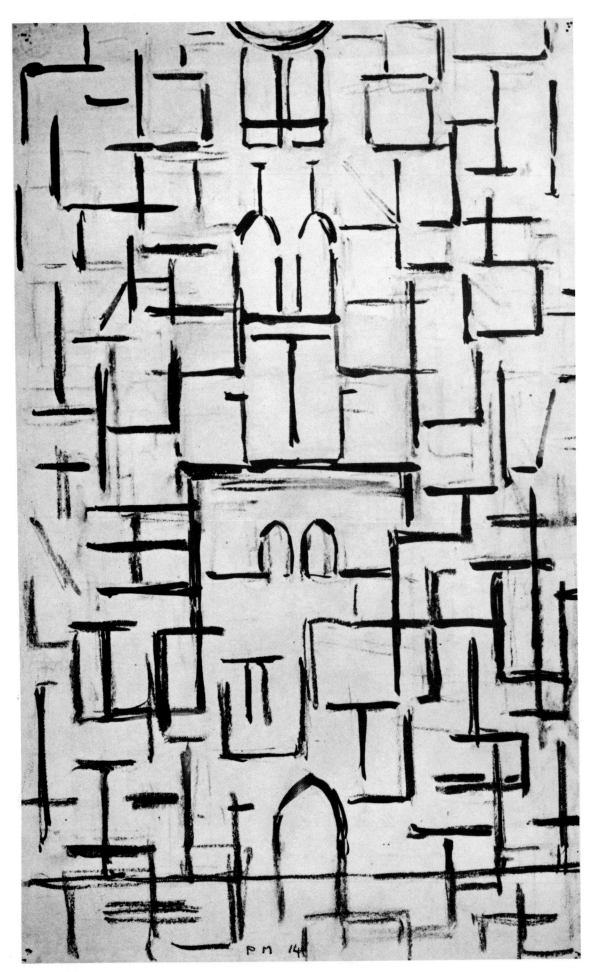

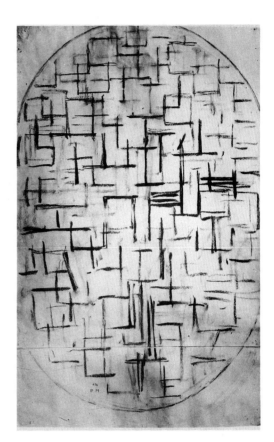

kept their gaze steadily cast on the future, lived in their own time and with awareness of their artistic and spiritual task: "At present, Neo-Plasticism manifests in painting what will one day surround us in the form of sculpture and architecture" (*De Stijl,* III, 18). Mondrian's painting, and that of the other Stijl artists, is thus a preparation, a prologue, and also a guide to a new, harmonious environment for future humanity, to a new world and a new life. The way to its realization goes from painting, via architecture and city planning, to influence humanity through the visual environment to such an extent that the whole style of human life will also become harmonious, and mankind will realize, in all aspects of society, the harmony that it has seen embodied in its everyday surroundings.

It is no accident that the way should pass via architecture, the spatial, three-dimensional presence of harmony: "Despite everything it would be perfectly possible, or rather it is becoming possible, to create buildings that are pure expressions of what is unchangeable, of what remains identical for each generation" (*De Stijl,* III, 31). In the Stijl movement Mondrian had been in close contact with architects. Gerrit Rietveld, Cornelis van Eesteren, and J. J. P. Oud (figures 57, 58, 59) belonged to this small group of pioneers, and in point of fact Mondrian saw in architecture one of free art's steps toward the new life. Here his dream of the future began to be a reality.

Mondrian dreamed this great utopian dream, of creating a future paradise for mankind, down to its smallest details: the dance, music, the stage, everything entered into his vision. But by nature he was unfit for taking the step from the utopian model to the practical realization of the dream. He was an ascetic and purist, prophet and mystic seer of a law that, to use Flaubert's words, "keeps to the middle way between music and mathematics." He was not the man, however, to engage in the practical rebuilding of his environment. To make the dream into reality, another type of person was needed, one who dared to tackle the reality of his time and change it. And Theo van Doesburg was such a man. Not satisfied with the certainty that sooner or later the world would be changed to accord with the principles of De Stijl, van Doesburg felt the urge to bring about the renewal without delay. Therefore this gifted painter became an architect; therefore, from the very beginning of De Stijl, he drew architects into the group—Oud, Rietveld, van Eesteren, and Robert van't Hoff, Jan Wils, Frederik Kiesler. He always wanted to forge ahead and to see the buildings of his imagination, as witnesses of a new spirit,

67
Church at Domburg/1914
Drawing, India ink on paper, 24 3/4 × 19 5/8"
Gemeentemuseum, The Hague (Collection S. B. Slijper, on loan)

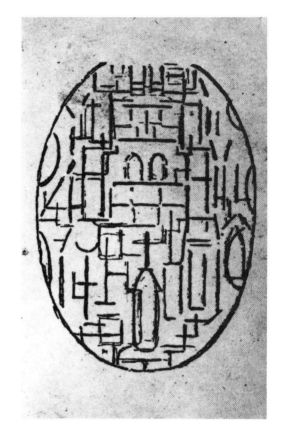

outline themselves against the obsolete forms of the past.

But the dream, the utopia, preceded this embodiment, and just that, the creation of an aesthetic utopia for human society, is Mondrian's great accomplishment. In his essay "Toward the True Vision of Reality," written in English in New York at the end of his life, Mondrian described the road he had traveled as a painter in order to arrive at his great design: "Our way leads toward a search for the equivalence of life's unequal oppositions. Because it is free of all utilitarian limitations, plastic art must move not only parallel with human progress but must advance ahead of it. It is the task of art to express a clear vision of reality." This is the road that Mondrian traveled as a painter; he found the way, as painter, as artist, and as human being. And, despite all the difficulties of practical life, he never departed a step from his chosen path.

This path of Mondrian's painting is impressive for its straightforwardness and consistency. His calling, his vocation as an artist, he regarded as a ministry, bringing total dedication and unfailing faith to the task that he and his friends were engaged in for the benefit of mankind. Throughout all the long years of neglect, loneliness, and poverty, he never compromised with his art, with his convictions.

"First of all we must have the strength to keep from regarding the material factor as the most important one. But that requires the spirit of self-sacrifice. We should begin by giving ourselves to an ideal: for the present, the new society exists only to the degree that we desire it. We ought to begin by forming an image of what that society must one day accomplish in all fields. . . . If finally the new man re-creates nature in terms of what he has become himself—nature and non-nature as a balance of equivalents—then man shall have reconquered—and for you, too—paradise on earth!" (*De Stijl,* III, 77). For this purpose, for the recovery of the felicity of mankind, Mondrian did indeed make many sacrifices. He devoted his entire life and his entire career as a painter to this constant quest and ultimate finding.

Accordingly, Mondrian's road is an exceptional road for a painter, and his *oeuvre* an exceptional body of work in modern art. The man who was here at work went far beyond the boundaries laid down for painting in his time. But he did more than that. He showed painting a new function, and in his own paintings he made the new function of art, the new world view, visible to the beholder. Mondrian's art starts from the Puritanism of his ancestral and national milieu; it demands and carries out a purification of art, of its means and its vocabulary of forms; but ultimately it aims at purification of the viewer, of mankind, by the power of a visual revelation. It aims at *schoonheid* in the two meanings of the Dutch word—beauty and purity; it aims at bringing style not only into painting, but into men's lives.

"To enlighten mankind": that is the goal Mondrian's art poses for itself. The ivory tower in which he and his friends seemed to live was instead a lighthouse that gave an entire generation direction and a fixed point. Mondrian's art, as it evolved throughout his working life of over fifty years, is still a beacon today, flashing its creator's message: "What a beautiful task lies in prospect before art: to prepare the future" (*Cahiers d'art,* 1931, vol. VI, no. 1, p. 43).

Mondrian portrayed himself many times, especially in a series of fascinating drawings (figures 2, 4, 5, 7, 8). But the 1918 self-portrait in oils occupies a place apart: except for an ink drawing of 1942, it is his last self-portrait, and since it is the only one that shows him clearly as a painter, it is more than ordinarily autobiographical.

The self-portrait was painted on commission from S. B. Slijper, Mondrian's admirer and friend from the time of his residence in Laren. With his large but selective collection of Mondrian's works, Mr. Slijper has erected an enduring monument to his friend. It is therefore fitting that this self-portrait has been chosen to introduce the colorplate section of this book, in homage to Mr. Slijper.

The picture shows Mondrian in half-profile, turned to the left, with head and shoulders inclining slightly backwards. This pose is a familiar one, used in a series of self-portraits drawn in 1912 and 1913. The glance is directed toward the viewer, as it always is in a self-portrait, and thus creates a link between the world of the viewer and that of the artist.

The artist's world is evoked by Mondrian's having portrayed himself against a painting on an easel in the background, parallel with the surface of the portrait. And this painting is related to the 1917 series of compositions in areas of color, the first works in which the principles of neo-plasticism are clearly expressed: the expanding composition and complete abstraction, that is, the absence of any bond to a perceived fragment of reality. Although the painting shown behind the artist's head cannot be identified with any of the five existing compositions with color planes dating from 1917, it clearly shows the characteristics of this series, which marks the breakthrough to a new style.

This gives the painting a genuinely autobiographical reference. Here Mondrian has connected his portrait with one of the paintings with which he achieved a feat in the history of twentieth-century art. It is evident from his writings in *De Stijl* and his later autobiographical comments that he was aware of the importance of that feat. In such a modest and unpretentious man as Mondrian, this awareness and the expression of it in a self-portrait are all the more important.

It is also noteworthy that the 1918 self-portrait closes the series of Mondrian's self-portraits. The reason for this cannot be the fortuitous circumstance that it was painted on commission from Mr. Slijper and that no such commission ever came to Mondrian thereafter. He could have been expected to continue sketching self-portraits, as he had previously done. But except for the 1942 sketch there are no others, and the reason for their absence must be that after 1918 Mondrian had entered so deeply into "another world," the world of harmony and abstraction, that he could no longer find any occasion for doing his own likeness, for a self-portrait.

Self-Portrait

Painted 1918
Oil on canvas, 34 5/8 28 3/4"
Gemeentemuseum, The Hague
(Collection S. B. Slijper, on loan)

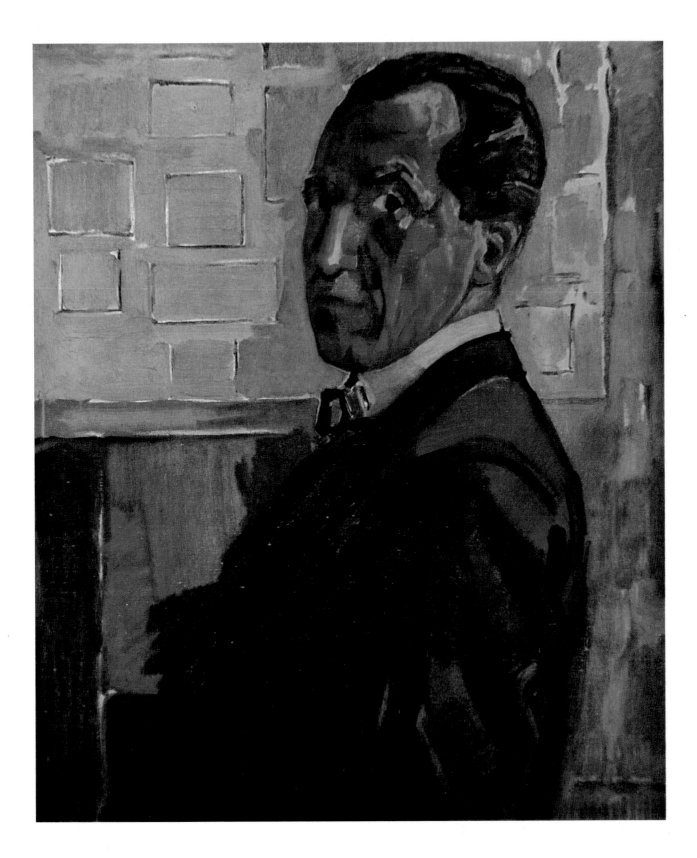

This painting, one of Mondrian's earliest works, was done when the painter was eighteen. In the previous year, on December 11, 1889, he had received his "Acte Tekenen L. O.," the diploma that entitled him to teach drawing in primary schools. As we know, Mondrian continued his studies after this first examination and on September 10, 1892, received his "Acte Tekenen M.O.," entitling him to teach in secondary schools. His family had urged him to work for both licenses as a safeguard against the uncertain career as an artist which he wished to pursue. He was helped in his studies by his father, Pieter Cornelis Mondriaan, Sr., who was the principal of a Calvinist elementary school and also a talented amateur artist, and when possible by his uncle, Frits Mondriaan, a much younger brother of his father and a professional painter who, as a pupil of Willem Maris, was a member of the younger group of the Hague school of painting.

The influence of the Hague school on young Piet Mondrian is evident in the painting *Dusk,* not only from the subject but also from the title, from the treatment of light and space, and in fact from the entire approach to the reality that inspired the work. In this little canvas he shows the craftsmanship he had attained under his uncle's direction. He also shows, as was almost inevitable in a budding artist of eighteen at the end of the nineteenth century, how much he was caught up in the convention of his teacher's generation.

After picturesqueness, mood was the most important watchword of the Hague school; this picture complies with both. Its title, *Dusk,* already suggests a mood, the idyllic mood of departing day. And the contrasts of the dark fringe of the woods, the clouds, and the effects of light in the evening sky emphasize an extremely picturesque approach to landscape—the flat Dutch landscape, with its changing light and ever-varying mood, that was the main subject of the Hague school, the slightly belated offshoot of the Barbizon school.

This little 1890 picture must not be regarded as a work indicative of future genius. It is nothing more than a test of competence, a starting point, and, for the painter himself, proof that he has acquired the means requisite to his craft. *Dusk* is a conventional bit, no better and no worse in quality than similar works by Mondrian's contemporaries, and if there is anything individual to note, it may perhaps be the stringent way in which the composition is built up out of horizontal planes.

Dusk

Painted 1890
Oil on canvas, 10 1/2 × 17"
E. V. Thaw, New York

This picture is dated 1900 on the basis of a closely related watercolor. The house represented can be identified by the date 1741 attached to the façade with wall clamps as the house now numbered 76 Gein North. The painting is a good instance of Mondrian's manner and ideas around 1900, when he was twenty-eight and had just started painting landscapes in the surroundings of Amsterdam. His friendship with Simon Maris, who was then working along the Gein River and in the neighborhood of the town of Weesp, may have been a reason for choosing this particular location.

Typical of the early Mondrian is the loose brush stroke, giving the impression of a direct oil sketch of the subject in the open air. This picturesque touch is characteristic of most of Mondrian's work during these years, not only the studies but also the finished paintings; it is probably one of his earliest accomplishments as a painter. A free flexible stroke was to remain a distinctive feature of his work down to his last pictures; his brushwork, mark of the experienced painter, always gave Mondrian's canvases their special vividness.

In its manner of painting and its color, *House on the Gein* is suggestive of a work of the Hague school. It also shows a relationship with the quiet canvases of Eduard Karsen, who infused similar subjects with a poetic mood of his own. The liveliness of the touch would seem to show an influence from the art of George Hendrik Breitner, the master of the so-called Dutch impressionism, whom Mondrian admired enormously at that time. For a young artist, it is nothing unusual to be subject to a multiplicity of influences.

The individual and really remarkable element in this painting is its clearly accentuated composition: the triangle of the house, forming a diamond with its reflection. Also noteworthy and personal, precisely for the years around the turn of the century, is the use made of reflection. During those years Claude Monet was engaged in using reflections in the water to dissolve the form of things into a maze of colors and brush strokes (figure 15); Mondrian, however, employs the reflection to amplify and consolidate the form, to give it structural support.

In this approach, in this conception of nature, young Mondrian shows his individuality and independence. To be sure, the theme of reflection is to be found everywhere in the Netherlands. But in those years there was no Dutch artist who used it, or at least certainly not in this way. In Mondrian's preference for the structure of the painting, apparent so early in his career before he had been in contact with similar trends abroad, we may see a foreshadowing of his ultimate goal, the harmony that, over and above the subject, is to constitute the content of the work.

House on the Gein

Painted 1900
Oil on canvas, 16 1/2 × 12 1/4"
Collection Mr. and Mrs. Carl H. Gans, New York

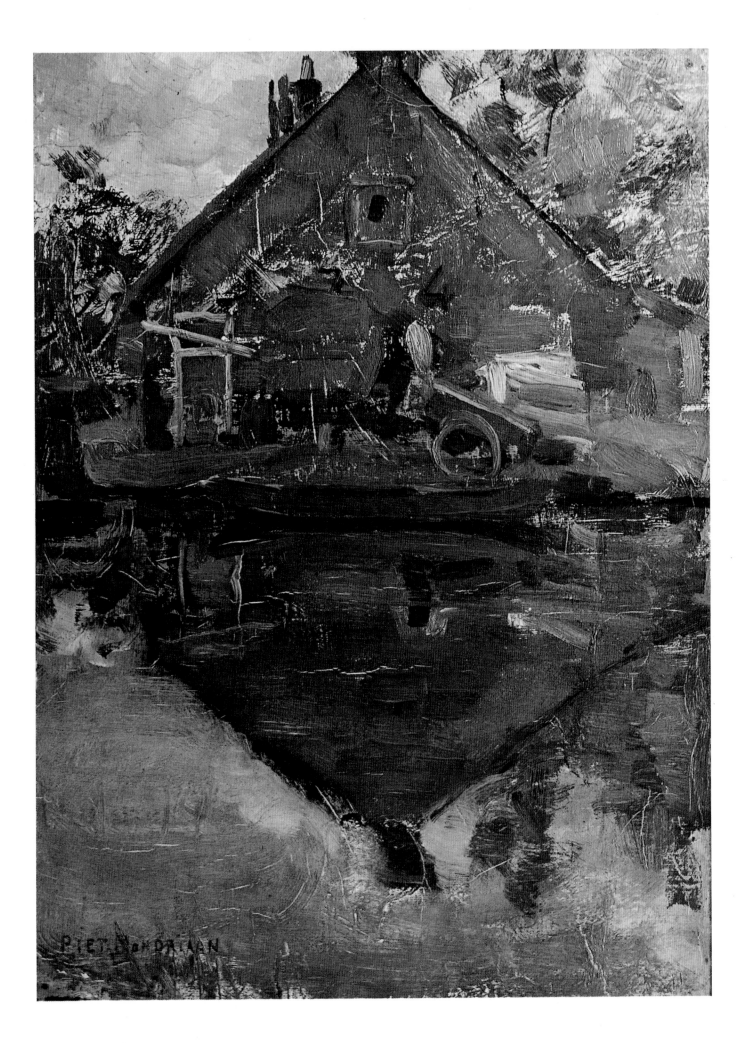

The dating of this picture is uncertain, but the principle of its composition and the manner of its painting coincide to such an extent with the *House on the Gein* that it is reasonable to assume a chronological connection. In this picture too, which is in light tones of green and a scintillating gray, the touch is airy and free, so that at first sight one would think of a nature study done outdoors. Mondrian sketched the trees vividly and surely in wet paint, and rendered the leaves with loose and rapid strokes.

But the total composition is in vigorous contrast to this impression of rapid and spontaneous manner. Once again Mondrian uses the reflection of the trees in the water to obtain a solid and rhythmically exact composition, one that seems to form a fabric of warp and woof. Horizontal and vertical bands are so intertwined that they confer on the painting a firmness, an architectonic order, based on precisely the element—reflection—that at that time was being used elsewhere to weaken the architectonic structure of a painting, making form and color appear to the viewer as a kind of mirage. Mondrian's personal vision, his striving for clarity and order, seems here already to be breaking through the conventions of nineteenth-century style. He has firmly grasped an optical fact, at the time commonly employed to blur forms, and made it reinforce and consolidate the architecture of the painting. We may assume that this picture, with its careful deploying of the subject matter on the pictorial surface, was the starting point for a series of later works showing clear similarities to the theme selected here—in particular, the drawing (figure 27) and the painting *Trees on the Gein, with Rising Moon,* dating from 1907/8, in which Mondrian departed from natural color and combined a strictly limited palette with taut formal structure. But this early painting shows points of correspondence with other views of trees along the Gein, especially with two canvases dating from 1907 and 1908 (figures 28 and 29), without however attaining to the stylistic innovations of these later works in coloring and strongly two-dimensional treatment. The *Trees on the Gein* of the first years of the new century is typical of a style that is still caught up in the rather provincial orientation of the Hague school, but in which the artist's striving for form begins to manifest itself in a treatment of form that is not conventional but compositionally functional.

Trees on the Gein

Painted 1902 or 1905
Oil on cardboard pasted onto panel, 12 1/4 × 13 3/4"
Gemeentemuseum, The Hague

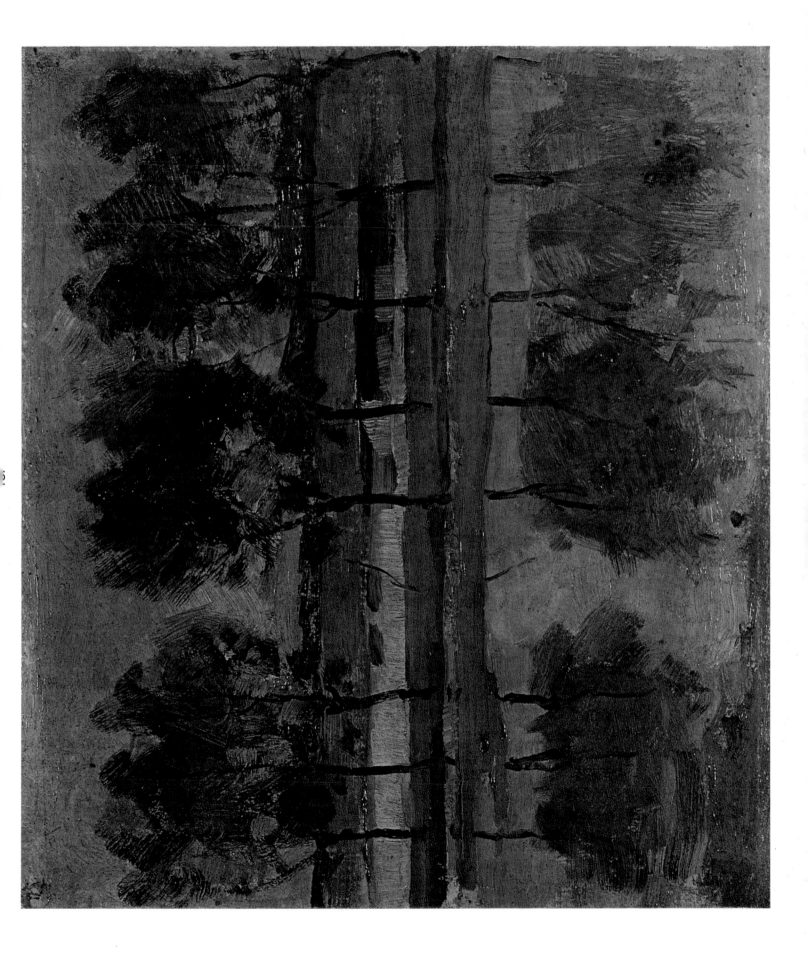

Windmill

The version of *Windmill* here reproduced, one of a number of similar but different versions dating from around 1905 and 1906, is typical of Mondrian's orientation in this period of his career. At the same time the painting shows a favorite theme of his while he was in the Netherlands: windmills silhouetted against an unbroken sky above a low horizon. This theme even recurs in the dialogues on modern art that he published in *De Stijl*, and in which he defended the right to existence of an art no longer bound down to a subject.

Together with the series of works based on the theme Farmhouse at Duivendrecht, this 1905/6 *Windmill* embodies the features then representative of Mondrian's art: it is outstanding for its careful observation of detail, for its highly sensitive and allusive depiction of evening light, and for the mood thereby evoked. These characteristics also apply to the work of the Hague school and much other nineteenth-century painting. But upon closer scrutiny we see that it was Mondrian's intention to make this observation of detail and light serve a compositional purpose. And that is what is particularly striking in this picture, what makes it a fascinating link in the chain of Mondrian's work. When one compares this canvas with many other paintings of the Hague school, and even with the other versions that Mondrian painted of the same subject, one cannot fail to realize the taut control of the composition: the division of the picture into horizontal bands, alternately light and dark, and the great dark form of the mill, a vertical thrust against these horizontal strata, its strength re-emphasized by the reflection in the water, which supports the dark silhouette like a pedestal. A number of details confirm this compositional intention: the sails of the mill, which further accentuate the horizontal course of the bands in the painting; the lowest dark band above the horizon, which coincides exactly with the line of the gable of the little house that terminates the composition to the left. These details, and many more, are put into the service of Mondrian's striving for rigor and order.

The order and serenity that emerge from this painting make it a fine example of this period in Mondrian's work. He looks for calm and harmony in nature, but he realizes perfectly well that it is precisely the task of the artist to make this harmony visible, to free it from the fortuitous play of appearances.

Painted 1905/6
Oil on canvas, 25 1/4 × 31 1/8"
Collection Mr. and Mrs. William R. L. Mead, Belmont, Massachusetts

TOP

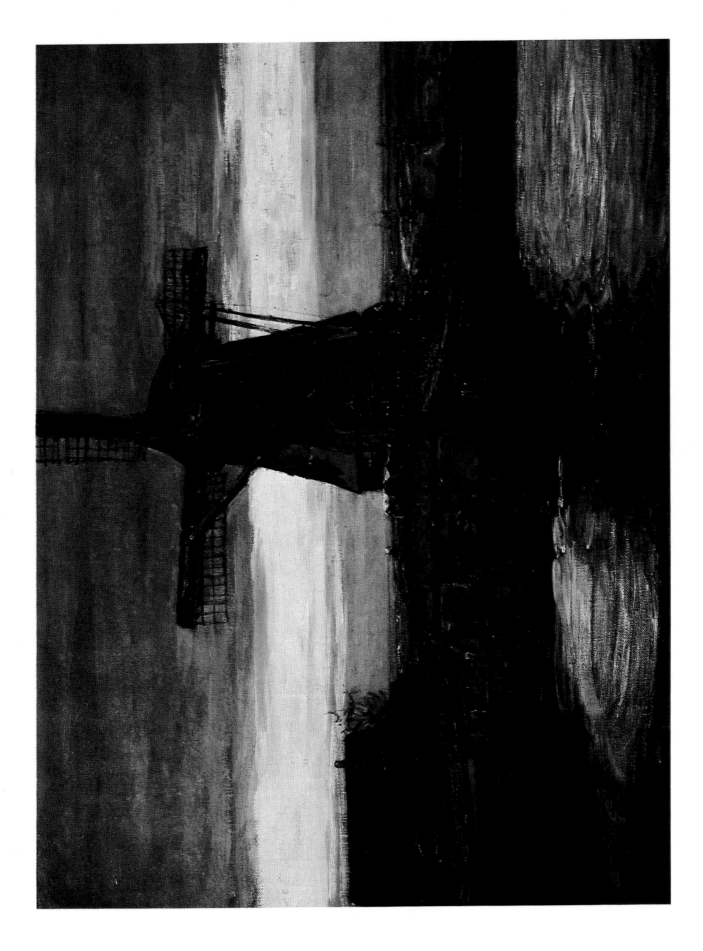

The Red Cloud

Painted 1907
Oil on cardboard, 25 1/4 × 29 1/2"
Gemeentemuseum, The Hague

This 1907 painting is convincing evidence of the renewal in Mondrian's painting, of the fact that he had succeeded in freeing himself from the conventions of the Hague school and had found the link to the new conception of painting that was making headway everywhere at that time: expressionism, or French fauvism, or in any case the trends in European painting which plainly emphasized the importance of color. The so-called Quadrennial Exposition that was held in Amsterdam in 1907, and in which such Dutch artists as Kees van Dongen, Otto van Rees, and Jan Sluijters exhibited—men who accentuated color in the new sense as the most important of means—may well have been the stimulus for this reorientation in Mondrian's work.

The Red Cloud has come to the Gemeentemuseum in The Hague as a gift from Mondrian's friend A. P. van den Briel, through whom it can be given the date of 1907 and localized in Oele, a village in the far eastern part of the Netherlands. This picture is an entirely different type of painting from the works that have served to illustrate Mondrian's evolution up to this point. It is actually a sketch, a work set down on cardboard in free rapid motion, catching the strong and wondrous impression of a brief but revealing natural phenomenon.

Here too we can see the mastery that Mondrian, at thirty-five, had attained in the use of his pictorial means. Although he painted the *Red Cloud* with the greatest freedom and speed, he did so with a sureness that did not misplace a single stroke or add a single unnecessary accent. Against the thin paint of the pasture in the foreground, set down in vivid dashes, and the light-blue of the luminous sky, the powerful form of the red cloud contrasts as a great splash of color. The brush strokes are visible, and the red, which increases in intensity as it goes upward, is modulated as if in a sequence of tones. It is color, as an independent emotional value, that dominates this painting and sets its stamp on it. The aim of the artist's quest is no longer the equilibrium derived from the forms of visible nature; he has discovered color and realized how its power can disrupt a previously attained equilibrium. A new period of search and experiment proved necessary in order to integrate color into this striving for equilibrium, an urge that was deep-rooted in Mondrian's character, education, and artistic formation. But it is typical of him as an artist and as a man that in this quest for equilibrium and compositional structure he strove to introduce ever-new elements he had discovered himself. *The Red Cloud* is a proof of this enlargement of his horizon, a sign of mastery, as well as the starting point for a new and rich development.

Woods near Öele

Painted 1908
Oil on canvas, 50 3/8 × 62 1/4"
Gemeentemuseum, The Hague
(Collection S. B. Slijper, on loan)

This large canvas, whose subject has been identified by Mondrian's old friend, A. P. van den Briel, as the woods near the village of Oele in the Twente district of the eastern Netherlands, evidently marks a milestone in the painter's work. It shows the phase of his art in which his horizon opened up and he began to look beyond the somewhat narrow boundaries of the Dutch school. To be sure, it was Dutch artists who had opened up vistas toward more spacious regions for him. Among these artists in particular were Jan Toorop, then the representative of a "luminism" based on the experiments of the neo-impressionists, and Jan Sluijters, who, after returning from Paris (and his Prix de Rome), was the leader of a forward-pushing younger generation desirous of escaping the confines of the Hague school's aesthetic creed and taking part in the rebellion of a generation (their own, born about 1880) which had broken out everywhere in Europe.

There exists a preliminary study (figure 19) for the painting, probably done on the spot, and a drawing reproducing part of the theme. The painting itself is clearly a transitional work. On the one hand it belongs, with such canvases as *Trees on the Gein, with Rising Moon*, to a period in which a scene of nature is brought to sober, almost solemn simplicity by means of rigorous stylization and stringent two-dimensional treatment. On the other hand, the color, the brushwork, and the rhythm of the painting betray a dynamism that indicates foreign influences. These trends in the painting of the early twentieth century—not just fauvism, but also the linear excitement of the Jugendstil and the fierce expressive accents of Edvard Munch's paintings and prints—had hitherto passed Mondrian by. His art had arisen out of a highly personal interpretation of the idiom of the Hague school.

Now Mondrian made a breakthrough to a broader vista. He not only adopted a new technique, another way of painting, but his view of reality changed. This can be seen from the fact that he could agree with a description of this painting given by the writer and critic Israel Querido in a review of the January 1909 exhibition of Mondrian's work, along with that of Cornelis Spoor and Jan Sluijters, in Amsterdam. Referring to the canvas by its exhibition title, *May Morning*, Querido stressed its symbolic content. It must have been at about the time he made the painting that Mondrian began to be interested in theosophy, an interest that led to his joining the Netherlands Theosophical Society on May 25, 1909.

The new view of reality, the realization that there are forces existing in nature related to those of human feeling and thought, stimulated Mondrian to attempt a fresh approach. And so, constantly painting, he went on from this great transitional work to develop an original style that gave clear expression to his belief in the forces of life, in the power of light and color. The *Woods near Oele* is at the threshold of this new period.

Along with trees and windmills, the two subjects Mondrian liked best in his early period and those used here to illustrate the course of his development, a third theme was added in the years from 1908 on, when he went to the island of Walcheren in the southwestern Dutch province of Zeeland every summer. This new subject was the lighthouse at Westkapelle, near Domburg, where he stayed. The painting here reproduced may well be the first version of the subject, perhaps done, together with a drawing of the same subject (figure 55), during his first trip to Walcheren. The picture has many points of resemblance to the *Woods near Oele* painting, which is to be dated from somewhat earlier in the same period. The severe, slightly curved lines bounding the mass of the tower, the lively forms of the clouds, the coloring, in which a remarkable purple tone predominates: all these features and many other details of the *Lighthouse* have a parallel in the *Woods near Oele.*

What Mondrian achieved in both paintings, and what evidently was his chief concern in this year of 1908, was the evocation of a strong and yet dynamic monumentality. Combining suppleness of form with a large, impressive treatment, he was able to approach this goal, and to reach it he seized upon such subjects as the tall woods near Oele and the mighty, lonely lighthouse soaring up against a cloud-filled sky. The way in which the huge vertical mass of the tower rises in this painting above the low, faintly indicated horizon, and the fact that this mass fills the picture almost to the upper edge, helped him achieve his intention.

These works of a transitional period recall the paintings of the great Norwegian artist Edvard Munch, who lived from 1863 to 1944 and was thus Mondrian's almost exact contemporary. There is no evidence that Mondrian ever saw original works by Munch, and it is meaningless to assert an influence merely on his possible acquaintance with reproductions. (It should be remarked that the purported influence is all one-way, from Munch to Mondrian, not from Mondrian to Munch.) One of the strongest elements of correspondence between the two men's work is the coloring, but in the reproduction processes possible at the beginning of the twentieth century all nuances of color were lost. Nevertheless, Mondrian's 1908 *Lighthouse,* for example, shows a distinct conceptual similarity to the entire structure and pose of Munch's 1907 portrait of the German statesman Walther Rathenau (figure 14).

Although we cannot point to any direct link between Munch's art and that of Mondrian, one fact does emerge clearly from the series of Mondrian's works marking the transition to 1908 and connected to some extent with his first stay in Domburg, where a significant number of Dutch artists and intellectuals spent their vacations at that time. This fact is that Mondrian had broken free from the narrow boundaries of provincial Dutch art and found his way to the major currents of European art. After 1908, Mondrian was more than just another painter of the Dutch school.

Lighthouse at Westkapelle

Painted 1908
Oil on canvas, 28 × 20 1/2″
Gemeentemuseum, The Hague

Windmill in Sunlight

Painted 1908
Oil on canvas, 44 7/8 × 34 1/4"
Gemeentemuseum, The Hague
(Collection S. B. Slijper, on loan)

The windmill theme, which has such an important place in Mondrian's work (see page 17), led him in 1908 to create one of his masterpieces in the new luminist style. Of all his luminist works, this picture perhaps exhibits the characteristics of the style most clearly, not only the technical, external characteristics, but also the inner, spiritual attitude that is so sharply rendered by the blazing sunlight.

Most striking in this painting is the choice and shading of the colors. Although Mondrian uses a series of nuances and gradations, his palette is here actually limited to three colors: the three primary colors of red, yellow, and blue. The significance of this limitation is that he is now experimenting with color in an effort to find the simplification and generalization that he had hitherto looked for mainly in form. In this he was aided chiefly by his contact, via his Dutch friends, with French fauvism and neo-impressionism. The Dutch art that had influenced Mondrian's early years was anything but coloristic; all of nineteenth-century Dutch painting was dominated by tonalism, in which the tonal value, the nuance, was regarded as more important than color itself. Of all the Dutch painters of the nineteenth century, only Vincent van Gogh went beyond the limits of this tradition, and then only after he had come in contact with the new colorist school in France, the impressionists.

It is no accident that some people tend to discern van Gogh's influence on Mondrian in the *Windmill in Sunlight.* Mondrian certainly could have seen exhibitions of Vincent's work, the large one in Amsterdam in 1905, for example, but it seems doubtful that the revivification of his color goes directly back to such an impression. A much more plausible assumption is that Jan Toorop (figure 16) and Jan Sluijters (figure 17) were the intermediaries between the heirs of Vincent's colorism in France, the fauves, and Piet Mondrian, the Dutch painter in quest of a way of painting that could render reality in a less fortuitous, more universal manner.

It is typical of the development of Mondrian's art and early twentieth-century painting in general that color was the initial step to renewal. For before turning to the problem of form, European painting as a whole first developed a new vision of reality through the fierceness, the expressiveness of color. Just at the time when Mondrian was concerned with the revival and simplification of color, Picasso and Braque in France had advanced to the problem of form, handling it in a way—cubistically—that was later to be important for Mondrian. For the time being, Mondrian faced different problems. In 1908, with the *Windmill in Sunlight,* he succeeded in reducing all his joy in radiant reality to the bright-sounding chord, the triad of primary colors, in which his vision of reality, and his optimism, found expression.

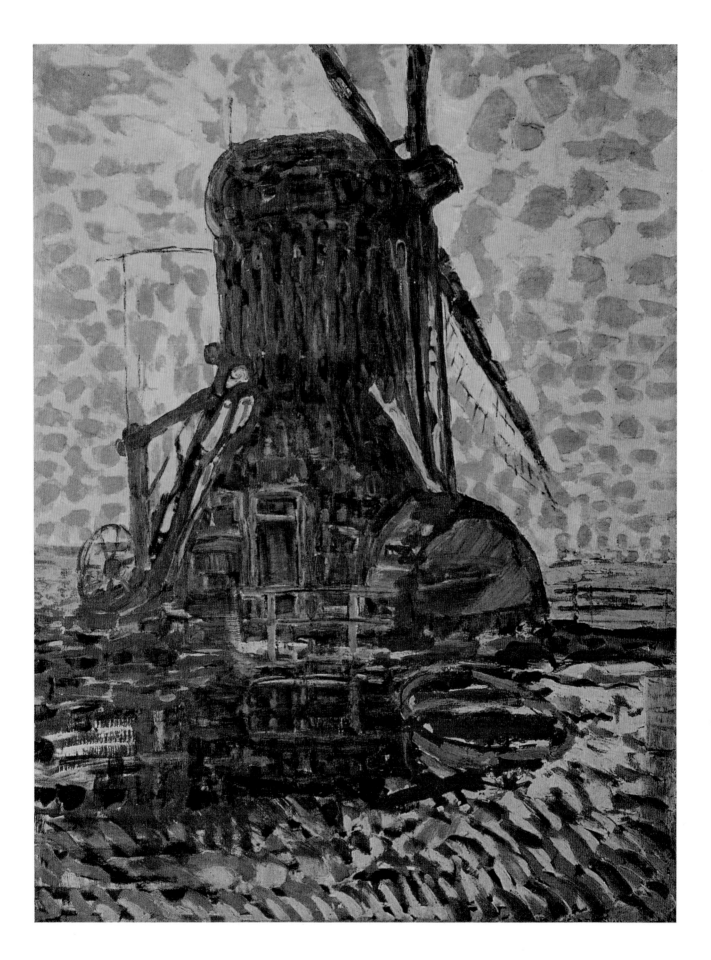

This painting, one of the most important in Mondrian's series on the tree theme, was done in the same year as the *Windmill in Sunlight.* In its color range and brushwork, and above all in its conception of nature, it shows many points of contact with that other picture. Here too there seems to be a definite influence of Vincent van Gogh's work. The painting recalls certain of Vincent's pictures of trees, particularly olive trees and cypresses, in which the brushwork, along with the simplification of color, plays so important a part. But reference to these paintings is not by itself sufficient to explain the origin and character of the *Red Tree.*

A good deal is known about the history of this canvas. There are several sketches and studies for it, making it possible to assign the picture its place in Mondrian's evolution. The remarkably thoroughgoing simplification of the color range and the trend toward nonnaturalistic colors, much more evident and decisive than in his previous paintings, are the most striking characteristics of the canvas, confirming the emphasis on color that preoccupied Mondrian throughout 1908. In that year, during which his horizon opened out toward international art, color was his chief concern, the most important new factor. And the way in which he here revolts against tonalism and collects his entire experience into the concordance of blue and red shows him for the first time to be an independent discoverer, an artist capable of developing a style of his own.

But this individual, personal style is not marked by the new acquisition of color alone. With respect to form, also, the *Red Tree* ranges far beyond the initial impression of nature. For comparison with the preliminary studies makes it evident that in the painting Mondrian has interpreted his impression of reality, transformed it into an idiom of his own: all the details of the tree's appearance, which in nature give a spatial effect, are straightened out on the pictorial surface, so that the linear structure of the brush strokes produces an almost completely flat impression. The spatial dimension of depth is suggested by the color, by the deep blue that Vincent van Gogh identified with infinity. This use of color, this intense and spatially suggestive contrast of red (close by) and blue (receding), has a meaning that is not merely descriptive. As David Lewis points out, supporting his contention with quotations, it is primarily symbolic and evocative. This means nothing other than that in this painting Mondrian wanted to set down his entire vision of nature, his credo as regards the world: the calm prevailing over the entire picture, despite the violence of the tree's movement, is that of an equilibrium—the equilibrium which Mondrian wished to triumph over the tragedy of facts.

The Red Tree

Painted 1908
Oil on canvas, 27 5/8 × 39"
Gemeentemuseum, The Hague

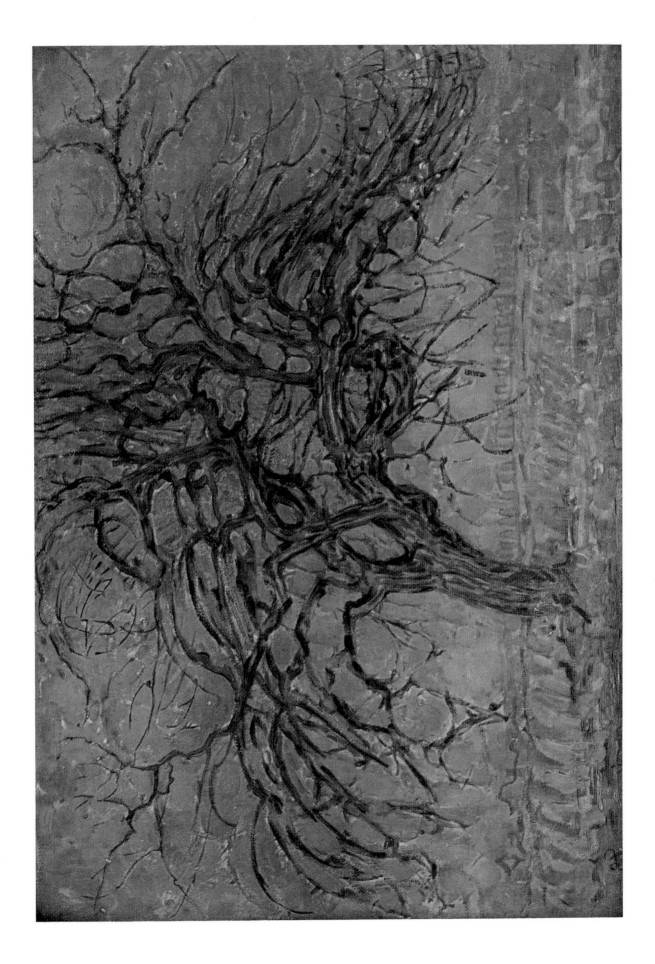

In the evolution of Mondrian's art, this small work, painted on cardboard in a loose pointillist technique, clearly belongs with the preceding works of 1908, such as the *Red Tree* and *Windmill in Sunlight*. There is an obvious contrast between this version of the lighthouse at Westkapelle and that of 1908 (page 63), in which the painter's attention was mainly directed at the monumental appearance of an imposing mass surging upwards against a low horizon.

In this little sketch, the accent is on entirely different aspects of the pictorial possibilities. Color has by now taken its place of importance in Mondrian's work, and he is no longer concerned with the clearcut contrast of a thing with its surroundings; on the contrary, the divisionist technique enables him to fuse things with their surroundings into a large and convincing unity. And this is what one sees happening in this little picture. The soaring mass of the tower merges with the upward movement of the color of the sky, producing a consonant, vibrating totality of great purity and power.

This year of 1909, in which Mondrian gave such evident proof that he was in the center of the movement for the renewal of painting in Europe, began with a joint exhibition in the Amsterdam Stedelijk Museum of the most recent work of Cornelis Spoor, Jan Sluijters, and Mondrian. At that time Jan Sluijters was the leader of the Dutch avant-garde. In 1906 he had won the Prix de Rome of the National Academy of Art in Amsterdam, and had traveled to Rome, Madrid, and Paris in the following year. Especially in Paris, the capital of art, he affiliated himself with the latest movements, with fauvism in particular. His art, however, like that of his Dutch comrades-in-arms, was also influenced by neo-impressionism, the pointillistic analysis of color, which had been initiated by Georges Seurat in the 1880s and had been continued and propagandized in the early 1900s by Paul Signac. The Dutch current, which stressed chiefly strong color and directness of touch, was called "luminism," because the painters aimed at a convincing depiction of the power of light.

This was the group with which Mondrian worked and exhibited. At that moment, therefore, he belonged among the foremost leaders of the Dutch avant-garde. His use of color, his stippling technique, the way in which he could evoke the unity of nature by means of his vivid color, secured him his place. But for Mondrian, as for many a French painter of the same generation, fauvism proved to be a way station on the road to a new style for the future.

Lighthouse at Westkapelle

Painted 1909
Oil on cardboard, 15 3/8 × 11 5/8"
Gemeentemuseum, The Hague
(Collection S. B. Slijper, on loan)

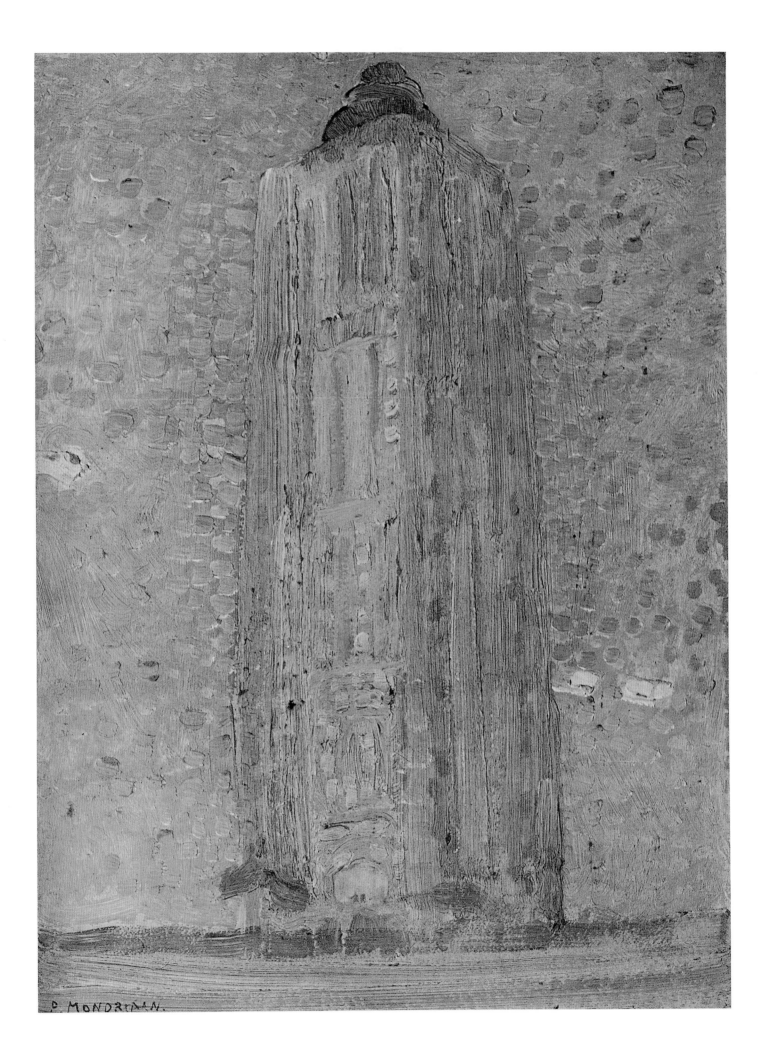

Along with the lighthouse at Westkapelle, it was largely the motif of the dunes along the Dutch coast that inspired Mondrian during his Zeeland period to a new flight of his pictorial imagination. This dune theme was something new to him, virtually the first appearance in his work of nature in its vastness and all-encompassing magnitude. To be sure, Mondrian had always been a landscape painter, but the subject of the nineteenth-century Dutch paysagist was never nature in the sense of unspoiled creation, of forms and vistas scarcely touched by man. All the places in the Netherlands where Mondrian worked during the first part of his career—the neighborhood of Winterswijk; the surroundings of Amsterdam, especially along the Gein and the Amstel rivers; the town of Uden and other localities in rural Brabant; the village of Oele and the nearby Twente district—had this much in common, that the most prominent features of the landscape were man-made: the farms, the reclaimed land, the Dutch system of canals. Not until he reached the island of Walcheren did Mondrian encounter nature in its endless breadth, which the Netherlands possesses only at the shore, along the line of dunes. This new experience made a deep impression on the artist, as can be seen from the series of studies he made at that time on the theme of the dunes and the sea. His confrontation in 1909 with the infinity of nature coincides with his joining the Netherlands Theosophical Society (May 25, 1909), where man's union with the infinitude of the universe was a central problem.

The painting here reproduced is an example of this new vision. It is not the first sketch of the new subject—that first sketch may perhaps be identified as a somewhat smaller work on cardboard, possibly dating from the preceding year—but a study of the theme itself, treated in the same manner as the little 1909 painting of the lighthouse at Westkapelle (page 69). The luminist technique (flecks of color set down in small touches) makes the large shapes of the dune merge with the sky above, giving an impression of the unity of nature, of a powerful and yet harmonious motion, of a quiet infinitude.

With these works, the first studies on the theme of the dunes and the pictures of the sea done during the same period, Mondrian began a reorientation toward a large integration of forms, which now once more receive the emphasis over color. A further stage of the same composition (page 73), in which the same motif is clearly recognizable and which must have been done at the end of 1909 or early in 1910, makes this change in Mondrian's conception of nature quite evident.

Dune II

Painted 1909
Oil on canvas, 14 7/8 × 18 3/8"
Gemeentemuseum, The Hague
(Collection S. B. Slijper, on loan)

The 1909/10 version of the theme of the Westkapelle lighthouse, a subject already familiar in two previous variants (pages 63 and 69), is a clear example of the change that took place in Mondrian's work after his interest had turned away from the luminist technique with its flecks of vivid color and returned to monumental form. But color now contributes largely to the richness and power of this form. The same evolution that takes place in the themes of the dunes and the windmills, and also in a way with the paintings in which a church is the subject, is evident in the theme of the lighthouse at Westkapelle.

Let us recall the presumed initial version of this motif, dating from 1908 (page 63), the painting whose supple monumentality is in such accord with the masterpiece of this first period of transition, the *Woods near Oele.* There the lighthouse stands, a vertical accent against a low horizon; flexible, lightly curved lines in a singular purple tone delimit the colossus against the motion-filled sky, in which the fanciful round forms recur that indicate the crowns of the trees in the *Woods near Oele.* Perhaps the most striking aspect of the painting is the dynamic character of the lines that sweep across the canvas in long hurried drifts.

After this work comes a small 1909 version of the same theme, in pointillistic technique (page 69), and another painting in the same style (now in a private collection in Milan), in both of which the emphasis is put not so much on the contrast between the lighthouse and its surroundings as on the unity of the world, of Creation and the man-made, through a total integration of the forms.

Between these two works and the picture here reproduced, dating from the end of 1909 and early 1910, there intervenes, as we may conclude from comparison with other drawings, a carefully worked-out ink drawing (figure 55) in which the main emphasis is on the structure. The drawing seems to have been made from closer up than the 1908 painting; a noteworthy feature is that the lantern is cut off by the upper edge. As a result, an impression of enormous size is created, of a force that cannot be contained by a sheet of paper.

This drawing is probably the basis of the painting reproduced here, which starts from the carefully studied structure of the tower and derives from that a powerful effect, an upward thrust, further augmented by the colors—a bluish purple, yellow, and white. Another aspect of the stress, which is now on the rhythm and not the form, is the fact that the sky on either side of the lighthouse occupies much smaller space.

Lighthouse at Westkapelle

Painted 1909/10
Oil on canvas, 53 1/8 × 29 1/2"
Gemeentemuseum, The Hague

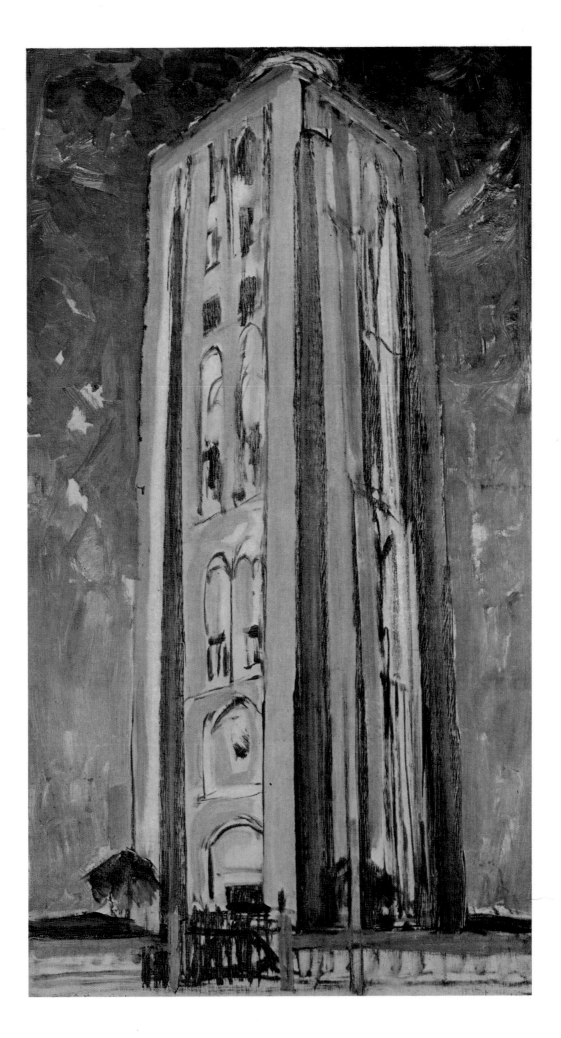

Church Tower at Domburg

Also dating from the period of the great monumental version of the dune theme is a painting likewise linked with the last versions of the Westkapelle lighthouse series but based on a different motif: the façade of the church at Domburg. The subject—architecture, church with a tower—appears early in Mondrian's work. A view of the choir of an unidentified church (now in the collection of J. P. Smid of Amsterdam) dates from 1892; there is an 1898 etching of the Reformed Church at Winterswijk; and from the first years of his visits to Zeeland, 1908 and 1909, there are two views of the church at Zoutelande on Walcheren, the first a side view, the second painted from directly in front in the pointillist technique that indicates the year 1909 in Mondrian's work.

The painting of the Domburg church here reproduced is also frontal in view and monumentally imposing. Like the latest version of the Westkapelle lighthouse (page 73), it is based on a preliminary drawing; the studies (figures 55 and 64) for the two paintings both date from 1909. The drawing of the church gives a very accurate inventory of the facts. In a few economical lines it describes the structure of the façade, the placing of the windows in the tower, the roof over the aisle, and any number of the details, such as the span of the buttresses, that characterize the façade. Even the little fence in the right foreground and the leaves of a tree, which interfere with the view of the top of the tower, are not forgotten. A drawing like this shows how precisely Mondrian took reality into account and then chose to concentrate on its structure.

In this painting, which manifests the same characteristics of style as the view of the dunes and hence must date from the same period—the end of 1910 and the beginning of 1911—Mondrian adheres closely to the drawing. But he undertakes to heighten the effect into monumentality by simplifying the planes and making the color tighter. The façade has become a huge area of brick red, broken only by the windows, in light or dark blue, and standing out against a blue-purple background. The surroundings are marked, to the right of the tower (where the drawing shows trees), by a blue area and elsewhere by a green area interspersed with purple-blue geometrical areas. Where foliage conceals the top of the tower in the drawing, dark blue triangles here intersect the structure. Mondrian has translated his observation of reality into a monumental vision. In the future he was to go still further, abandoning all recollection of the building proper and, in a series of drawings (figures 65–67), retaining only the rhythm.

Painted 1910/11
Oil on canvas, 44 7/8 × 29 1/2"
Gemeentemuseum, The Hague
(Collection S. B. Slijper, on loan)

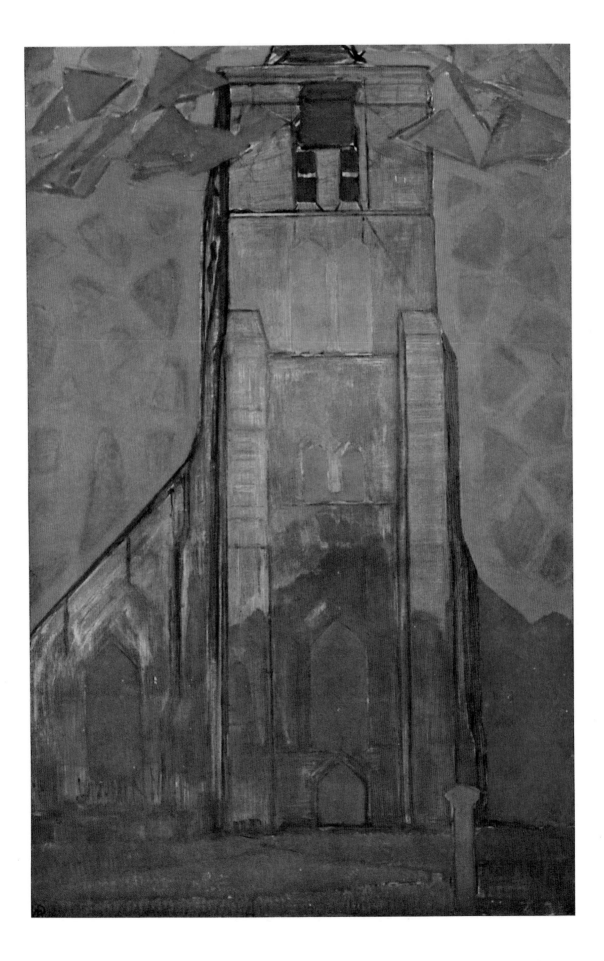

The windmill depicted in *The Red Mill* is of a type that seems to occur chiefly in Zeeland, thus indicating that Mondrian probably created the painting in Domburg. It terminates the evolution of one phase of his work. The painting is an excellent example of the ever-changing but always consistent treatment of a motif that runs through Mondrian's entire development. The 1905/6 *Windmill* (page 57) is an early instance of this theme, but even older canvases could be cited in which the same problem, the upward surge of the huge body of a windmill into the tenuous air, is the painter's starting point.

The 1908 *Windmill in Sunlight* (page 65) was a striking example of Mondrian's transition to a luminist technique, to purer color and a new vision of nature's unity. The primary colors that completely dominate this canvas, together with the lively fauvist touch, place the *Windmill in Sunlight* at a high point of movement and stormy vitality in Mondrian's work. The slanting light falls so strongly, so plashingly, in this painting that even the fierce colors of the *Red Tree* or the paintings of haystacks do not equal its effect.

In the *Red Mill* Mondrian has an entirely different purpose in mind. He is not aiming at expressing violent movement, but rather inward-directed calm, the still solitude of man in the midst of the universe. By means of an extreme simplification of color and form he achieves a monumental quality that makes of the mill a symbol of a world view.

It is not a coincidence that this painting of a windmill was done almost at the same time as a symbolist triptych showing three emergent human figures and called by the painter *Evolution* (figure 22). In it Mondrian's theosophical vision of man and cosmos takes form. Not only was his *Red Mill* done in the same year; it also shows many points of relationship with the triptych. The mill looks almost human, with a trunk and uplifted head, and the figures in *Evolution* seem, like the mill, to have their bodies rooted in the ground.

The symbolic content of Mondrian's mill coincides with a vision of reality in which things themselves are hardly of importance, in which mill and man are mutually interchangeable, but in which the point truly at issue is the place of the individual in the large unity. And the painting itself stands at a crucial juncture in Mondrian's development as an artist, at the end of one phase and the beginning of another. For at the very moment that the *Red Mill* and five other of his works appeared in the Moderne Kunstkring exhibition, Mondrian saw cubist painting for the first time—and the course of his life was changed.

The Red Mill

Painted 1911
Oil on canvas, 59 × 33 7/8"
Gemeentemuseum, The Hague
(Collection S. B. Slijper, on loan)

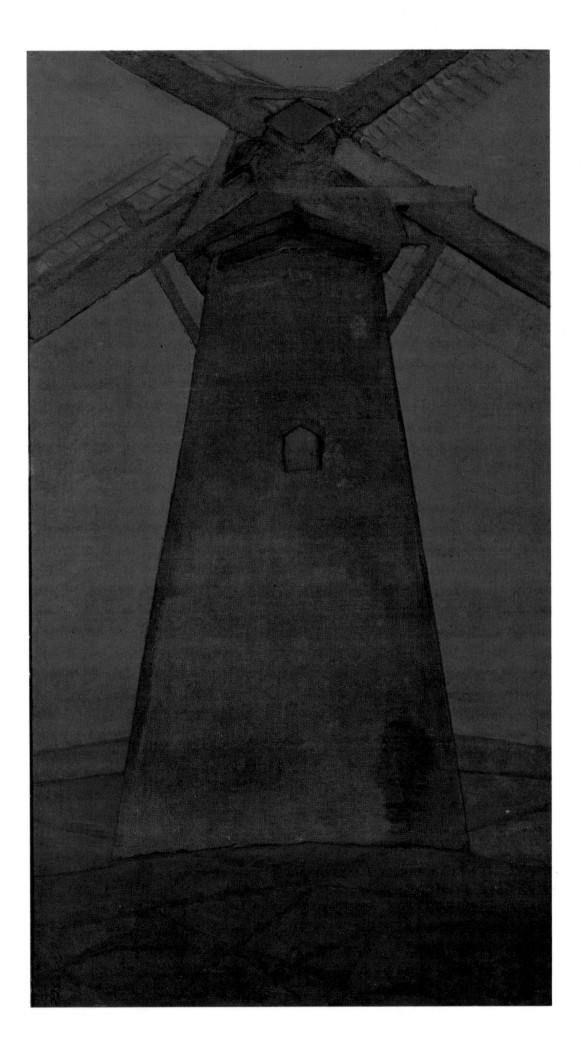

The two versions of the *Still Life with Gingerpot* bring out, more clearly than any other works do, the change that took place in Mondrian's painting at the borderline between 1911 and 1912, a change that was the result of the gradual reorientation of his art after 1909, with the accent falling less on purifying the color and more and more on forms and their symphonic interplay, on the composition. And it is certainly no accident that this change, this stride into another domain, was embodied in two still lifes. Mondrian had painted such compositions during an earlier period of his career—still lifes in the conventional manner of the late nineteenth century, done in 1892 and 1893 soon after he had got his licenses to teach drawing; he sent these canvases to the 1893 Kunstliefde exhibition in Utrecht. Still lifes, however, hardly play an important role in the body of Mondrian's work. With the exception of the flowers (figure 56) which he painted (and which are to be regarded less as still lifes than as symbolic portraits of a state of mind), there are only five still lifes in all. The two reproduced here are the last of them.

To understand the importance of the reappearance of still lifes at this moment in his development, we must do more than reflect on the impression that the aims and style of the cubist painters—Picasso, Braque, and so forth—at the Moderne Kunstkring exhibition undoubtedly made on Mondrian. What must also be taken into account is the fact that most of the cubist works in this show were still lifes. And an artist interested primarily in compositional values, as Mondrian at that time was, may well feel a special preference for the still life as subject matter. Before the painter has touched the canvas, he can set up his composition by merely ordering and arranging the objects as he desires. A still life on a table already embodies the compositional purposes of a painter more than any scene of nature can ever do.

The first version of Mondrian's *Still Life with Gingerpot* is a good instance of this loose but evident compositional ordering. A table stands in the midst of and is covered by the ordinary, everyday things in a studio—portfolios of drawings, canvases leaning against the wall, pots and pans, drinking glasses, a knife and a piece of cheese on a napkin. And centered on the table, its turquoise color and full round shape contrasting with all the rest, is a gingerpot. It dominates its surroundings just as much as do the Westkapelle lighthouse, the Domburg church, the red mill. The objects around it are accompanying voices which only lend greater emphasis to the central part, the gingerpot. In addition, the subdued purplish and ocher tones of the objects bring out the gleaming color of the gingerpot (the "hero" of this still life) even more strongly. The picture is still linked to the preceding period.

Still Life with Gingerpot I

Painted 1911/12
Oil on canvas, 25 7/8 × 29 1/2"
Gemeentemuseum, The Hague
(Collection S. B. Slijper, on loan)

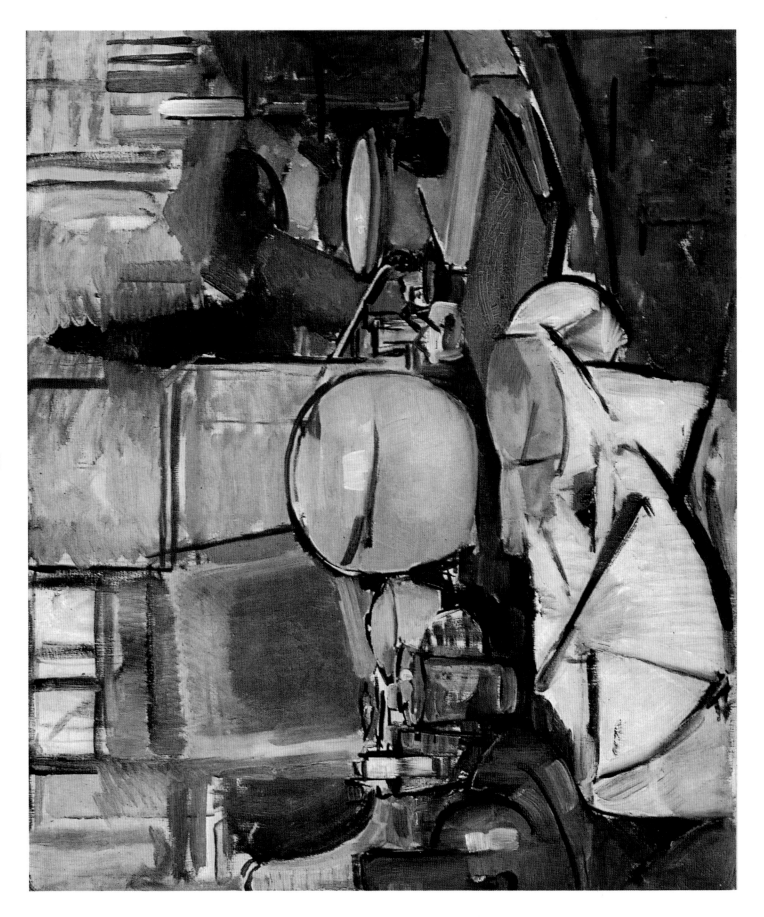

The second version of the *Still Life with Gingerpot*, done in the summer of 1912 after Mondrian had moved to Paris and begun to spell his name with a single "a," presents an entirely different conception. In the time that had elapsed between the two versions, Mondrian had assimilated the principles of cubism and drawn conclusions for his own art, in his characteristically thorough way.

A viewer comparing the two paintings as if inventorying merchandise might not discover a great deal of difference between the two. There is the same turquoise-colored gingerpot in the middle, with much the same sort of pans grouped around it to the right and the same sort of glasses to the left. But the role that these objects play in the painting has basically changed, marking a definite transition in Mondrian's work.

In the second version of the painting the objects have lost their character as objects and have become no more than notes in a score. Hardly anything is left of their independence, of their status as things, in the totality of the composition. This difference between the two versions comes out most clearly if one compares the foregrounds. What in the first version was a napkin with a knife on it, sloping over the edge of the table, has become in the second a white area traversed by a diagonal. Here we have at its most evident the transformation of a factual thing into a compositional value, a process in which the thing has to give up many of its characteristic properties. Or, in other words, the artist has abstracted the rhythmic form-value of a thing from its thing-value.

In this way there is an essential difference between the first and second versions of the still life. The first version is a still life of things, the second a composition of forms. In the first version the descriptive factor still sets the tone; in the second, only the interrelations of the forms are involved. The comparison between prose and poetry could be used to describe the difference between the two versions. And indeed a fact recurs that has its parallel in the art of verse, something that I should like to call "visual rhyme" or "optical alliteration": the round form of the gingerpot is twice repeated in round curves in the left half of the painting, and the pans on the right have been given distinctly accentuated covers in order to balance the diagonal movement in the foreground, a diagonal that was produced in the first version by a knife and the folds of a napkin. Here Mondrian took the first step on a road by which he escaped from the domination of things.

Still Life with Gingerpot II

Painted 1912
Oil on canvas, 36 × 47 1/4"
Gemeentemuseum, The Hague
(Collection S. B. Slijper, on loan)

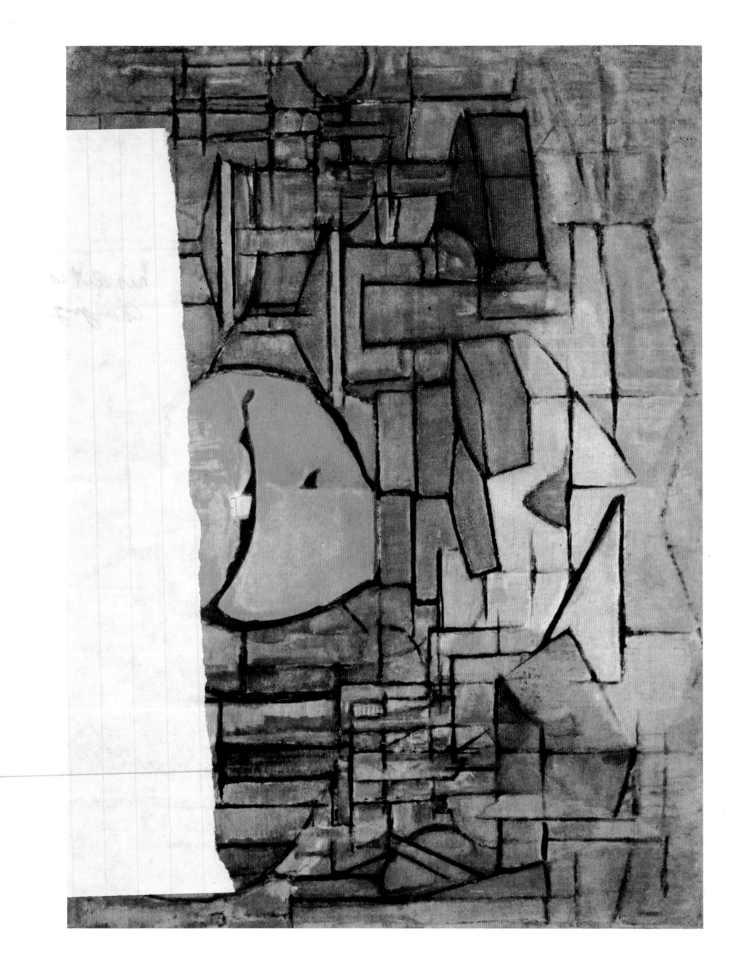

The Gray Tree is one of the first paintings in which Mondrian applied to a natural subject the principles of cubist composition that he was in the process of assimilating and working out in his own way. At the same time, it is a continuation of the series on the Tree theme, which began with the studies for the *Red Tree* (page 67) of 1908. Although four years elapsed between the *Red Tree* and the *Gray Tree,* it would be a mistake not to see them as two links in a single chain of development.

Actually, there are a few additional links in the chain connecting the luminist version of 1908, with its bold red and blue, and the cubist one of 1912, in which color has receded almost completely, and form and rhythm dominate. These additional links date from Mondrian's Zeeland period and comprise a number of little works that reached a highpoint in the *Blue Tree* (figure 24), probably created in 1910, the same year in which other motifs—dunes, mills, church façades—similarly acquired a character of their own.

In 1912, or perhaps as early as the winter of 1911/12, Mondrian came back to the theme of trees in a large drawing in black chalk (figure 25), in which his unmistakable aim was to bring the three-dimensional volume of the bare tree, with its twisted branches, onto the surface of the picture, into the second dimension. His project was to transform the thing that he saw in front of him into a rhythmic sign on his sheet of paper. This drawing became the starting point for at least three paintings: the *Gray Tree* reproduced here; a closely related canvas, somewhat more oblong in shape and thus a little closer to the drawing; and the *Flowering Apple Tree* (page 85).

It seems evident that the process which took place between the large 1911/12 drawing and the *Flowering Apple Tree* paralleled the change in conception between the first and second versions of the *Still Life with Gingerpot.* The *Gray Tree* is a little further along in that course of development than the first version of the still life; the factual qualities of the tree have already been converted into a rhythmic play of lines, leaving the thing-value of each part far behind. Nonetheless, a certain painterly quality is still an important factor in the appearance of this tree painting. It is an effect attained by vigorous brush strokes with smooth paint, and it has almost totally disappeared in the second version of the still life. The *Gray Tree,* in turn, seems a major and successful effort to translate the drawing of a tree, which had itself been executed with a primarily compositional purpose, into a painting embodying the principles of cubism, which Mondrian had mastered for himself in the interim.

The Gray Tree

Painted 1912
Oil on canvas, 30 7/8 × 42 3/8"
Gemeentemuseum, The Hague
(Collection S. B. Slijper, on loan)

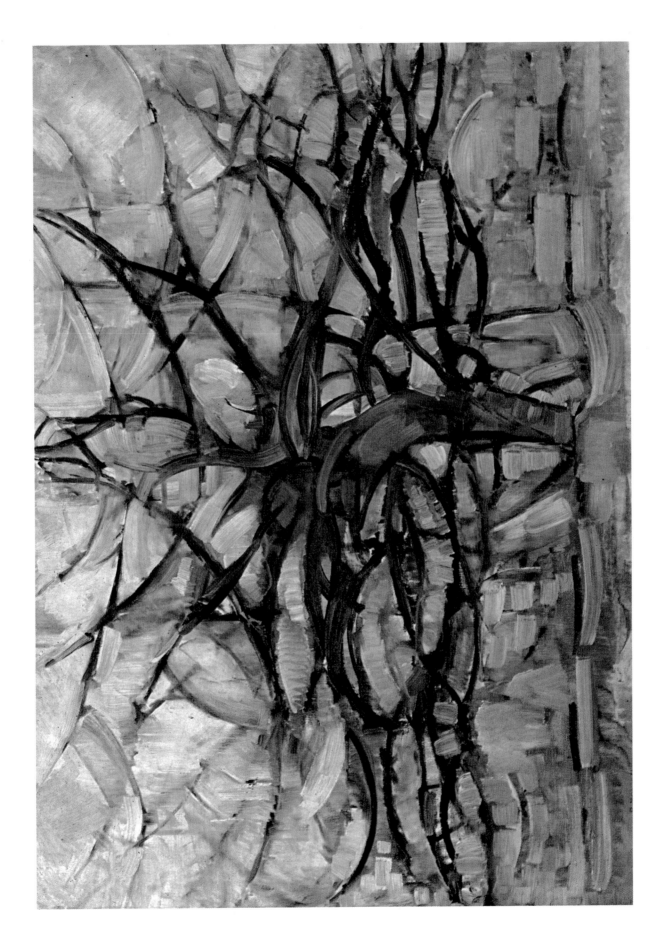

The *Flowering Apple Tree,* probably done in the spring of 1912, was shown in October and November of that year at the second exhibition of the Moderne Kunstkring in Amsterdam, together with the *Still Life with Gingerpot II.* The two paintings represent the same phase in Mondrian's development. Like the second version of the still life, the *Flowering Apple Tree* painting has discarded the descriptive function of the pictorial language and been transmuted entirely into the poetic forms of "visual rhyme" and "optical alliteration." The forms of the tree have lost all thing-value and are transposed into rhythmic accents in the composition as a whole.

This picture manifests, even more distinctly and convincingly than the second version of the still life, the characteristics of a cubist composition. Color has been reduced to the benefit of form, and the individual forms combine into a compositional totality that is obviously centripetal. In other words, the painting is scarcely colored at all; the painter's palette is limited to a few tints of green, ocher, gray, and purple. During the same period, the color scale of the Paris cubists was reduced to a few shades of ocher, gray, and brown. As for the form, the painting is clearly concentrated on the foci of an ellipse, as is so typical for cubist paintings (figure 26), with the aim of presenting the work of art not as an excerpt from nature but as an autonomous segment of reality created by the artist in conformity with laws of its own and unrestricted by surrounding actuality. Thus, in these paintings the four corners are left almost empty, since the entire power of the work is gathered together toward the center. An oval obviously encompasses such compositions more adequately than a rectangle, and this fact plays a recurring role in the course of the development.

As compared with the only slightly earlier *Gray Tree,* the *Flowering Apple Tree* is far less painterly in surface treatment. In the earlier work, telling strokes and accents defined the form; here a thinly applied layer of paint is the means by which the structure of the whole is brought out.

Despite the tendency of the painting toward abstraction—the paring down of form to essentials and then using this bare form compositionally—it possesses the tender lyric delicacy always associated with a flowering apple tree. For that reason we should not forget that Mondrian at this period, although strongly inclined to abstraction, continued to work from an impression of nature, translating it into his rigorous but still figurative language.

Flowering Apple Tree

Painted 1912
Oil on canvas, 30 3/4 × 41 3/4"
Gemeentemuseum, The Hague

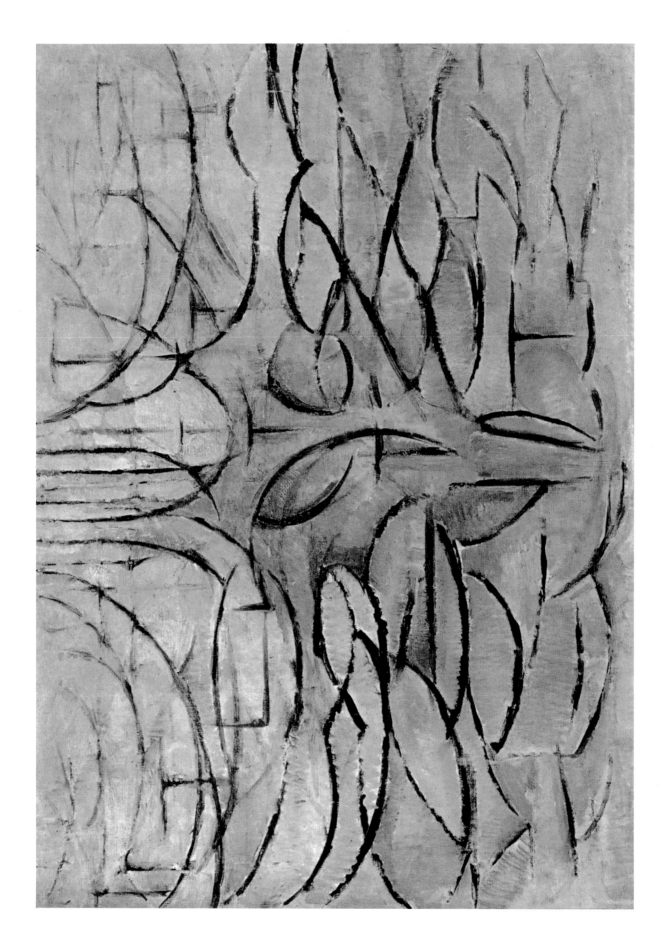

Oval Composition (Trees)

Painted 1913
Oil on canvas, 36 5/8 × 30 3/4"
Stedelijk Museum, Amsterdam

In this 1913 painting, which is encompassed by an oval line, with the area outside the oval painted in an ocher resembling gold, Mondrian came close to the ideal of a cubist composition that he had set himself upon his arrival in Paris early in 1912. Not only do the colors—a mixture of ochers, yellow, and gray—come very near to the works of the analytical cubist period of Picasso (figure 26) and Braque, but the entire structure, built up of *plans superposés*, is closely connected to those works. It should be noted that in the year in which Mondrian painted this first oval composition, Picasso and Braque had already left the analytical phase of their cubism behind them and were engaged, by means of the technical innovation of *papiers collés* (pasted-on papers), in founding a new, synthetic period of cubism, abandoning the segmentation of objects into facets with mainly linear boundaries. In this respect Mondrian's art lagged slightly behind the development of cubism.

In view of the fact that during this period Mondrian always derived the rhythmical composition of his pictures from some visual impression or experience, and the further fact that he gave the viewer a clue to the subject matter of this painting by adding *Trees* in parenthesis to the title, the question of the source of the composition is quite justified. I believe, with Robert P. Welsh, that the starting point of this painting is to be found in a sketch of some trees, surrounded by an oval line, on a sheet in one of Mondrian's 1911 sketchbooks (figure 31). Moreover, a drawing now in the Hague Gemeentemuseum seems to be related to the same motif; it must have been executed in 1911 or 1912. Some of its lines, especially the branching line in the central axis, follow courses similar to those on the sketchbook sheet, and also foreshadow the splendid charcoal drawing (figure 32) that is the immediate source of *Oval Composition (Trees)*. Some of the shadows that are clearly visible in the charcoal drawing and have been taken over in part into the painting seem to go back to this earlier drawing.

At any rate, the result that Mondrian achieves in this 1913 painting is far indeed from the first suggestion provided by an experience of nature. In this picture he embarks on a way that led him, in the wake of Picasso and Braque, to the outermost limits of analytical cubism, limits that Picasso and Braque themselves did not go beyond. During the next few years it was Mondrian who went beyond, removing cubist composition ever further from reality.

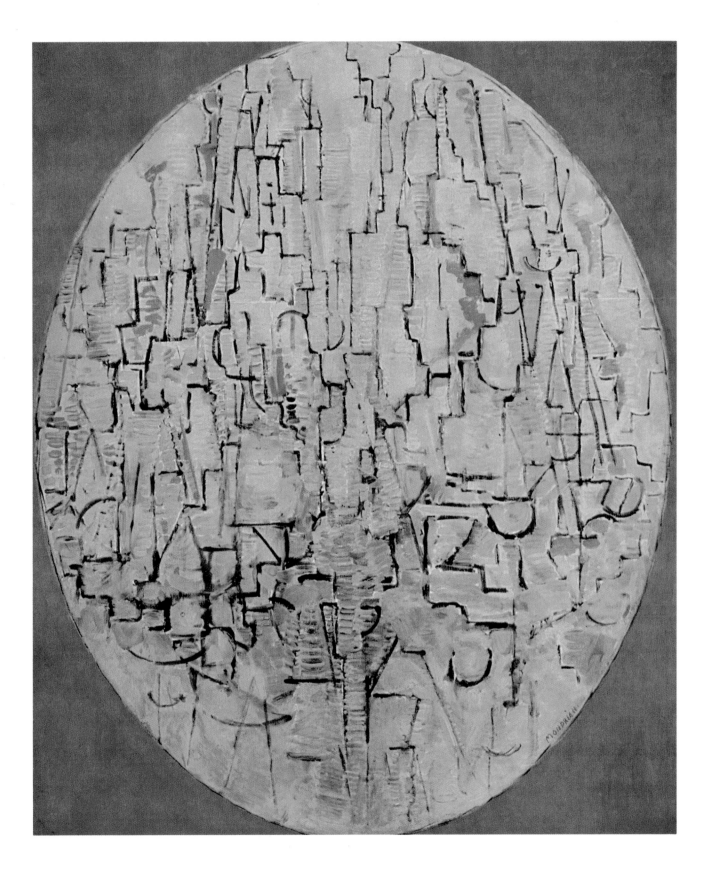

There is a genetic similarity between the *Blue Façade* and the *Oval Composition,* in addition to the fact that both must have been executed more or less in the same period, as 1913 went over into 1914. In my opinion, the *Blue Façade* represents a more advanced stage than the *Oval Composition,* as is evidenced by comparing it with contemporaneous works by the two founders of cubism, Picasso and Braque, who were also tending toward larger planes and a broader scale. Furthermore, and characteristic of his 1914 work in general, Mondrian has here arrived at total elimination of the curve and drastic limitation of the diagonal. Finally, the triad of colors used in the 1913/14 painting is reduced still further to a gamut of blue and blue-gray, which is also in agreement with the 1914 development.

This limitation of the color scheme to various tints of blue is also connected with the genesis of the work. The painting derives from a subject that Mondrian sketched several times during the first year of his stay in Paris: the side wall of a building still marked by the traces of a neighboring house that had been torn down. The sketchbooks of the Paris period contain at least half a dozen more. One of the sketches provides the key to the colors found in the painting: in various sections of the façade, which is subdivided almost geometrically, one can see the letter B or the letters DG. These letters indicate (and the painting itself makes this abundantly clear) the color to be used: *blauw* or blue, and *donkergrijs* or dark gray. Thus it is not only the formal structure that goes back to an optically perceived model, but also the color, which in this case the artist seems to have followed exactly.

Nevertheless, in such works as the *Blue Façade*, Mondrian took a great step beyond the boundaries of cubism. While synthetic cubism, on which Picasso, Braque, and now Juan Gris as well were working during these years, was again trying to establish a connection between geometrical forms and the objects of daily life, by starting with geometrical forms (cylinders) and making them resemble things (bottles), Mondrian advanced on the way to an ever-stricter abstraction, an ever-further departure from perception. This abstraction meant that very little of the thing-value of the original perception was taken over into the painting, the work being dominated by the rhythm abstracted from thing-forms during the creative process.

Blue Façade

Painted 1914
Oil on canvas, 37 1/2 × 26 5/8"
The Museum of Modern Art, New York (Purchase)

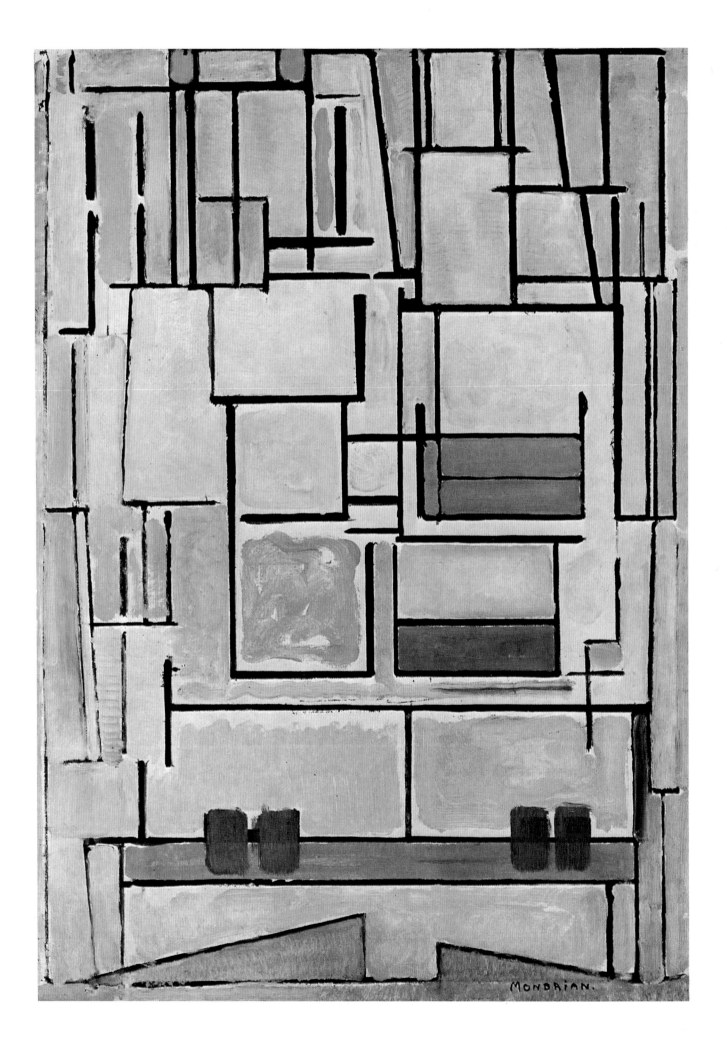

In June 1914 an exhibition of Mondrian's work was opened in The Hague, at the Walrecht Gallery. A few weeks later the artist was called back to the Netherlands from Paris, to the sickbed of his father. Then World War I broke out, making it impossible for him to return to France, although he insisted that he wanted to go. In the end, his family and friends were able to persuade him that any such attempt was useless. And so Mondrian was confined to the Netherlands for the duration of the war, cut off from the ambience of Paris which had inspired most of his work over the last few years.

He soon returned to the themes he had been concerned with in Zeeland and elsewhere before moving to Paris. He did a series of drawings of the church at Domburg (figures 65–67), conceived in accordance with the "abstract cubism" that he had developed in Paris. But in addition to this old theme he took up two particular new motifs, which were to occupy him for the first years of his enforced residence in the Netherlands: the sea, a subject that he had already handled in several works during his Zeeland period; and something related yet completely new—the theme of Pier and Ocean.

This title is perhaps too simple for the powerful series of paintings and drawings to which it is applied. What these works are actually about is the rhythm of the waves, breaking in a strictly circumscribed cadence against the structure built out at a right angle into the sea. As can be seen, the view is from above, for Mondrian first sketched the subject looking down from the dunes. In the first drawings, in charcoal, sometimes heightened with India ink or tempera, the pier is still clearly recognizable. In a drawing that can be dated 1914 (figure 35), however, this previously identifiable form jutting out into the sea (figure 34) has been translated into a vertical accent. According to Robert P. Welsh, the structure represented in this drawing was most likely a pier or breakwater at the Domburg beach; according to others and to the subtitle *Scheveningen* which the drawing bore when exhibited in 1915, it was the amusement pier at the beach resort near The Hague.

The work now known as *Composition No. 10: Pier and Ocean* epitomizes all the previous stages of this composition. It straightens all the elements that in earlier versions were indicated by oblique or indistinct lines. It reduces the rhythm of the waves and their breaking to a pure and simple pattern of lines, each precisely determinate in length and interval, like notes in a musical score. And yet this painting is remarkable precisely for the reason that this rhythmic abstraction from the unending movement of nature still proceeds visibly and demonstrably from an optical perception, even though it has been translated into an idiom in which only the rhythmic values count and all memory of the original subject matter has been lost.

Composition No.10 Pier and Ocean

Painted 1915
Oil on canvas, 33 1/2 × 42 5/8"
Kröller-Müller State Museum, Otterlo

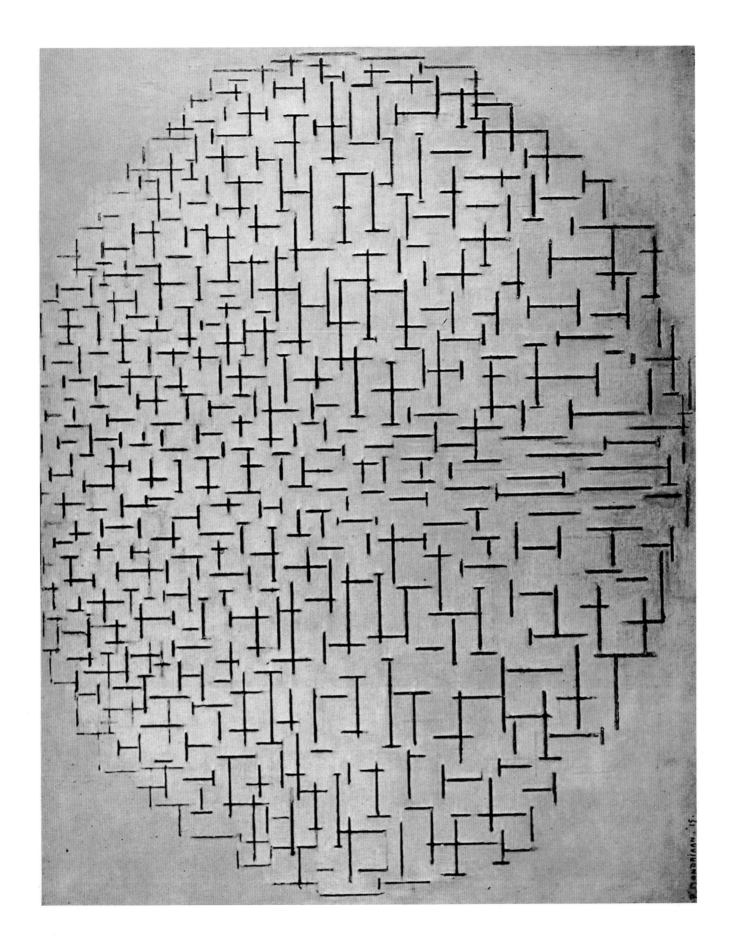

Composition, 1916

Painted 1916
Oil on canvas, 47 1/4 × 29 1/2"
The Solomon R. Guggenheim Museum, New York

This 1916 composition (signed and dated, lower left, on the wooden frame around the canvas, forming part of the whole) is an important link in Mondrian's development at the end of his cubist phase, during his enforced stay in the Netherlands during World War I. More than in any other of his cubist paintings he has reached a synthesis here between the rhythmic pattern of the lines and the refined color. It is just this that makes this painting a delightful intermezzo between the 1915 version of the Pier and Ocean theme (page 91) and its definitive completion in 1917 (page 95). In the series on this theme, the paintings are strictly monochrome, as the motif may perhaps have suggested; the emphasis is plainly and indisputably on the form.

Composition, 1916 is evidence that during these years of intense exploration of cubism, Mondrian was still concerned with the problem of color, and that his experiments in this domain no longer aimed at nuancing a single color in various shades, as in *Oval Composition (Trees)* and *Blue Façade* (pages 87 and 89), but were associated with his experiments with the triad of primary colors. These latter experiments went back to the 1908 *Windmill in Sunlight* (page 65), and, after the de-emphasis of color during his first cubist period, re-emerged in 1913/14, in the large *Oval Composition* and similar works of the last period of his stay in Paris before the outbreak of World War I.

The use of color and the structure of the linear rhythm suggest direct connections between *Composition, 1916* and a series of charcoal drawings that go back to the motif of the church at Domburg and were done in 1914, linking up with the 1910/11 painting (page 75). This varied series (figures 65–67) shows a constantly more subtle nuance of rhythm. From the general forms abstracted from the appearance of the facade, Mondrian arrives gradually at a freer but also more divided rhythm. The long-note values of the painting and of the first drawings (following the sequence suggested here) are subsequently broken up into eighth and sixteenth notes, yielding a lively and intensely moving rhythm. This rhythm is connected with the motif, and with the development of Mondrian's work, by the free use of the color.

And yet *Composition, 1916* seems to be a typically cubist work, only slightly differing from a preceding stage of Mondrian's extreme cubism. It is a sequel to the *Oval Composition* of 1913/14 and the large 1914 oval (frontispiece) in the Stedelijk Museum in Amsterdam. Typical of the essentially cubist nature of this painting is the fact that, despite its rectangular format, the centripetal composition characteristic of cubism remains clearly visible. On the other hand, a point is here reached beyond which no further straightforward development was possible.

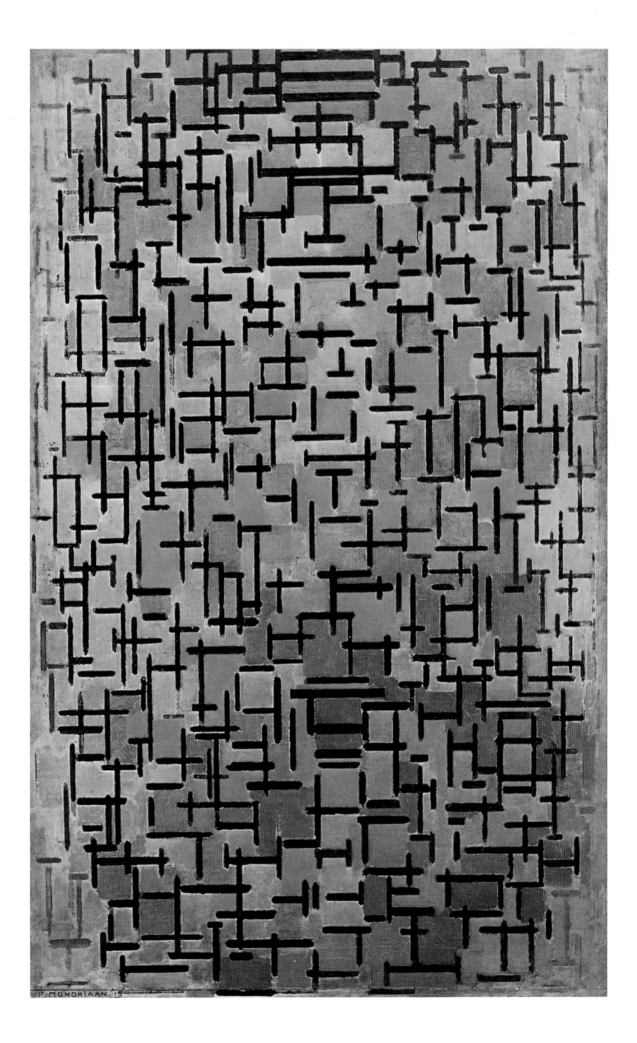

The *Composition with Lines,* dated 1917, marks the end of one phase in Mondrian's art. At the same time, this canvas may be regarded as the definitive version of the Pier and Ocean theme. Although the derivation of this composition from its predecessors may not be immediately apparent, the clear vertical accent rising from the center bottom toward the middle of the canvas stems directly from the lines of the pier in all the earlier versions (figures 34–36 and page 91), and the empty area, with only a few short line segments, just above the midpoint of the painting is related to the vacant spaces that appear in the corresponding region in the first studies of the subject. The dissolving of a visual perception into a rhythmic pattern is however carried out here in a still tauter, more forceful, and more economical manner.

But the special significance of this masterful painting lies in another direction: it is the last work by Mondrian that is based clearly and exclusively on cubist principles. This canvas clearly evidences the two main characteristics of a cubist composition, and especially of the first, analytic period, which Mondrian got to know in 1911 and to which he always remained faithful: the predominant importance of form as compared with color, and the centripetal tendency of every cubist work of art. In contrast to its immediate predecessor, the *Composition No. 10: Pier and Ocean* of 1915 (page 91), which has some touches of gray, the *Composition with Lines* is built up completely of black lines against a white background. The stark contrast is the only means of visual communication that Mondrian uses here.

The centripetal force determining the form of the painting can be recognized from the fact that the horizontal and vertical lines that state the form pull together into an ellipse or oval (which is actually almost a circle), the diameter of which is slightly larger than the sides of the square canvas. Thus, the movement of the painting is clearly directed toward the foci, whence originates the ellipse inscribed in the square.

Along with these cubist compositional principles, however, there is still another characteristic of Mondrian's works up to and including this painting which comes to an end here: the origin of the subject matter in something visually perceived. It is true that the paintings of the last few years, particularly those created during his involuntary stay in the Netherlands, went far beyond any visual starting point. Nevertheless, Mondrian's creative process demanded such a starting point before advancing into abstraction in the literal sense of the term: the drawing off of the essence from the appearance of things. All the works up to this point are executed as if by a kind of formula of progressive subtraction. After this painting, the process was to alter radically.

Composition with Lines

Painted 1917
Oil on canvas, 42 5/8 × 42 5/8"
Kröller-Müller State Museum, Otterlo

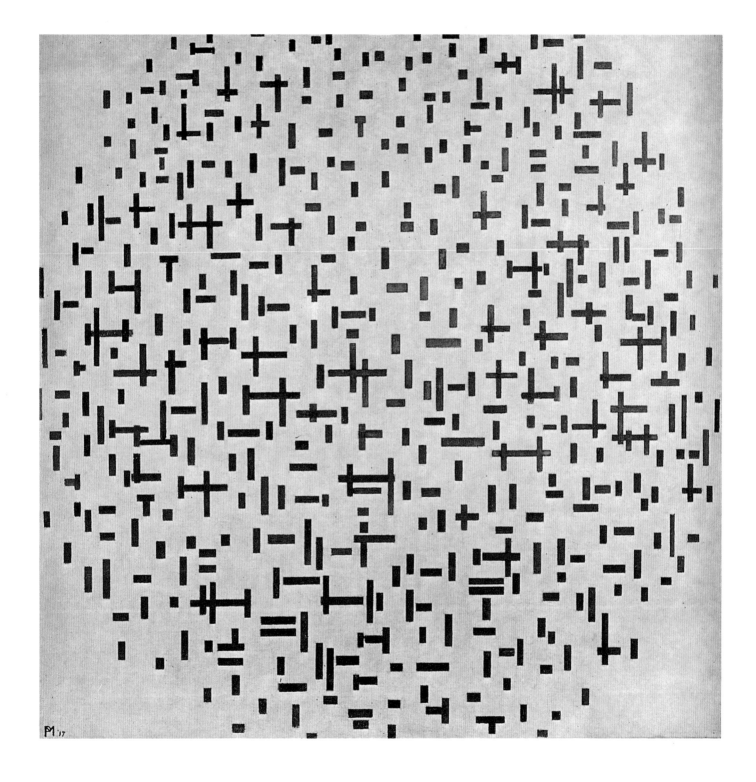

Composition III with Color Planes

Painted 1917
Oil on canvas, 18 7/8 × 24"
Gemeentemuseum, The Hague

The canvas reproduced here and four other similar compositions form the first clearcut step toward a new manner of painting in Mondrian's development. They are the first works showing the way to neo-plasticism. Mondrian himself must have been aware of the fact that this new conception meant a break in his work, since he chose a painting (or a design for a work) from this series for the background of the *Self-Portrait* (page 49) that he painted on commission for his friend S. B. Slijper. With what must have been deliberate autobiographical intent, Mondrian portrayed his own face against a work of the new painting, which was his creation, his feat.

The new and consciously different character of the *Composition with Color Planes III* as compared with the three works of the first half of 1917—*Composition with Lines* (page 95), *Composition in Color A,* and *Composition in Color B,* all of which were hung in the exhibition of the Hollandse Kunstenaarskring in May, 1917—is also evident from an observation made by Robert P. Welsh in the catalogue of the 1966 Mondrian exhibition. Mondrian originally signed the color-planes painting with the same monogram he had used on the three earlier works: PM (superimposed) '17. He then painted this monogram over and replaced it with a block-letter monogram and the date without apostrophe: P M 17. This was the type of signature he continued to use for the rest of his life. For an artist with as clear a mind as Mondrian's, this alteration of signature in 1917 certainly cannot be without meaning.

What then is the great difference that distinguishes this painting from all its predecessors? First, the fact that it is no longer based on cubist principles. In contrast to the cubist centripetal force, this painting is centrifugal: it does not tend toward a focus but spreads out, radiates, even beyond the boundaries of the canvas. In addition, color is not de-emphasized in favor of form, as is usually the case in cubist pictures; form and color here are a unity and work together to evoke a rhythm. And with these two purely pictorial facts goes another and even more important factor of principle. This work is the first one that obviously does not go back to a visual perception. Previously Mondrian had abstracted the harmonious rhythm from the accidental form of things; now he has achieved sufficient mastery over his means to be able to use these means—and nothing more—to express harmony. Between the group of paintings done in the first half of 1917 and the compositions with color planes there comes the founding of De Stijl. A composition by Bart van der Leck (figure 43) and one by Theo van Doesburg (figure 42) from the same period serve to make it clear that Mondrian's conquest soon became collective property.

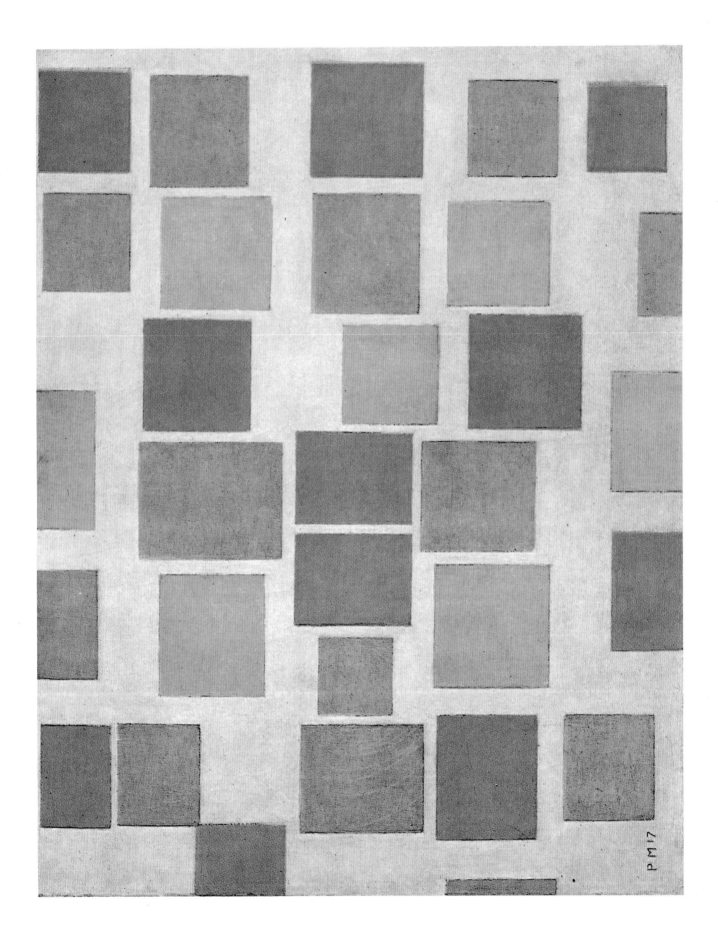

This composition in primary colors, dating from 1918, is the next step after the series of five compositions with color planes of 1917. It is also the work that inaugurates the long and uninterrupted series of neo-plastic paintings. Mondrian had found the solution he was looking for, and from this point on, throughout the years of his second stay in Paris (from 1919 to 1938), he kept varying, refining and completing it, but never essentially altering it. This painting, which is now owned by the Swiss artist and collector Max Bill, a truly kindred spirit of Mondrian's, is therefore of particular significance.

The difference in principle that distinguishes this painting from the series of works dating from the previous year is described by Mondrian himself in the last number of *De Stijl*: "Uniting the rectangles was equivalent to continuing the verticals and horizontals of the former period over the entire composition. It was evident that rectangles, like all particular forms, obtrude themselves and must be neutralized through the composition. In fact, rectangles are never an aim in themselves but a logical consequence of their determining lines, which are continuous in space; they appear spontaneously through the crossing of horizontal and vertical lines. Moreover, when rectangles are used alone without any other forms, they never appear as particular forms, because it is contrast with other forms that occasions particular distinction. . . . Thus the planes were not only cut and abolished, but their relationships became more active."

It is the first step in this development, a step already foreshadowing the next one, that is carried out in the painting reproduced here. By going back to the short-lined pattern of the first half of 1917 and then extending the line fragments vertically and horizontally in accordance with the new-won compositional principles, Mondrian links line and color together into a new unity. By means of the same new approach, moreover, he succeeds in wholly integrating the background and the colored forms, which in the works of the second half of 1917 still seem to float on the background. Space and form, background and color, are combined into a tight fabric, which coincides with the surface of the picture; yet the rhythm that has arisen on that surface is not limited to the boundary of the frame, but expands, overflows the bounds of the painting, filling the wall, the room, the life of man.

Composition: Color Planes with Gray Contours

Painted 1918
Oil on canvas, 19 1/4 × 23 7/8"
Collection Max Bill, Zurich

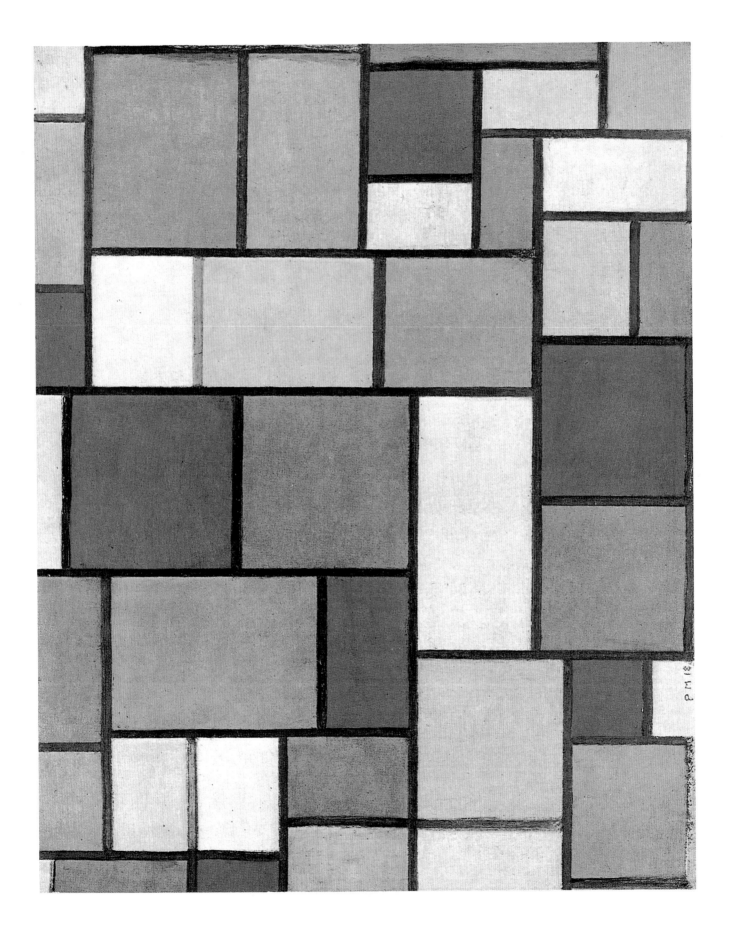

This work, signed in the bottom center and dated 1919, was probably done while Mondrian was still in the Netherlands, before his return to Paris. According to the municipal register in Laren, he was in residence there until July 14 of that year. Along with several works bearing the date 1918, the painting belongs to a series (some other specimens of which also have the same diamond shape) compositionally based on a geometrical subdivision. By the introduction of a subtle qualitative balance, however, this basic geometrical pattern has resulted in a newly free and harmonious composition.

The new compositional principle appears for the first time in a lozenge-shaped painting of 1918 (figure 45), now in the Gemeentemuseum of The Hague, which Mondrian presented to his friend A. P. van den Briel before leaving for Paris. Like a somewhat smaller version dated 1919 (figure 46), now in the Philadelphia Museum (Arensberg Collection), the square painting stands on one point and is divided by a system of parallels into 8 × 8 small squares, each of which in turn is divided into four triangles by a system of diagonals traversing the original square (and thus appearing on the lozenge as vertical and horizontal lines). This regular geometrical pattern, however, is given an asymmetrical qualitative equilibrium by means of thickening and darkening some of the lines, which is even more evident in the painting in Philadelphia than in the earlier version in The Hague.

This group of works comprises not only four lozenge-shaped compositions of 1918 and 1919 but also three rectangular canvases (one a regular square), dating from the same years. In the rectangular works (figure 49), the basis is also a subdivision into squares, which are then brought together into larger units by a system of lines, changing the symmetrical pattern into a rhythmic composition.

In the picture reproduced here, the geometrical division of the square into a checkerboard of 8 × 8 small squares is still clearly visible. In a way, the subdivision may be said to act like the scanning of a musical composition into measures, with the rhythm and the melody flowing over them, undisturbed but not unnoticed. The tension between measure and rhythm constitutes a large part of the charm of this painting. The rhythmical effect here, farther-reaching than in the versions in The Hague and Philadelphia, is supported by an accentuation of the rectangles thus formed by means of differences in gentle subdued hues. In the last analysis, however, this painting is an experiment in form, going back in a sense to the 1917 *Composition with Lines* (page 95).

Lozenge: Color Planes with Gray Lines

Painted 1919
Oil on canvas, 26 3/8" diagonal
Collection Marguerite Arp, Basel

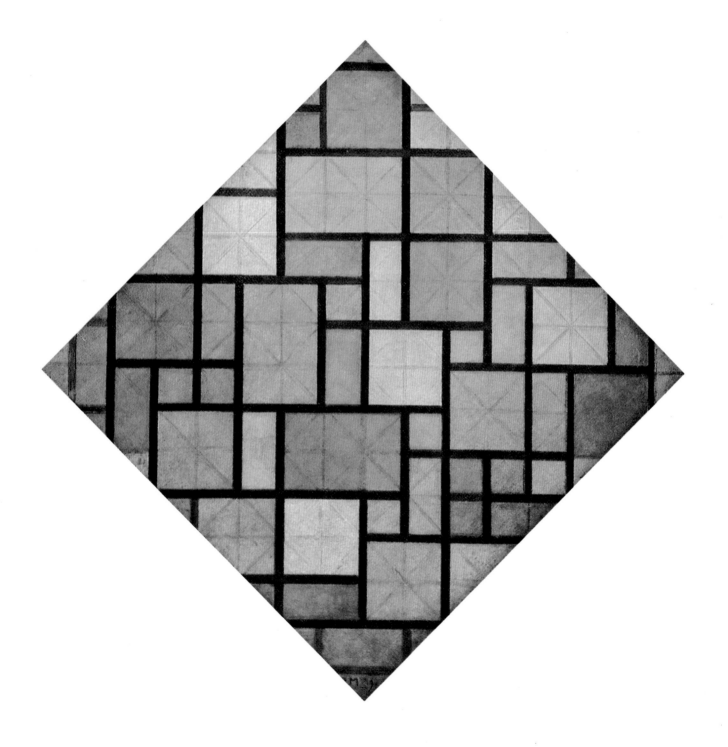

With the two compositions of 1919 that have been given the title *Checkerboard*, one in light and the other in dark colors, Mondrian turns from his experiments with a geometrical subdivision of form to similar experiments with color. In both compositions a rectangle (in the dark *Checkerboard* 33 1/8×40 1/8"; in the light, 33 7/8×41 3/4") is subdivided into 16×16 small rectangles, each of which has the proportions of the canvas as a whole. By this procedure a completely regular geometrical pattern is produced which serves Mondrian as the foundation for his rhythmic composition, created by means of color variations. By painting several adjacent rectangles the same color but keeping the linear pattern distinct, Mondrian achieves, in another way, a rhythmic action that traverses the grid like a musical rhythm flowing over the bar-lines.

In the *Checkerboard, Light Colors* this rhythmic configuration is attained by the primary colors red, yellow, and blue and by a number of gradations running from pure white to a gray about equal in brightness to the darkest blue employed in this composition. The primary colors used in this painting vary in intensity from square to square, and the grays seem to vary in character, sometimes by being mixed with red, sometimes by an addition of blue, and sometimes by a blending with both colors.

In the *Checkerboard, Dark Colors* Mondrian works in the same way, with tints of red, purple, and blue. Typical for both paintings is the manner in which the artist seems to have determined the color for each little rectangle by intuition and experiment. The paintings are not by any means executed according to a preconceived idea. The painter let himself be guided by his feeling for color and rhythm, and he made alterations and corrections as he worked; overpaintings to change the colors of some of the areas can still be detected. The skilled treatment and masterly balance of the canvases are the result not of a theory but of almost thirty years' experience as a painter.

In a sense, Mondrian's experiments in 1918 and 1919, first with geometrical division of the plane and then with color, go back to experiences of previous years—the geometrical experiments to such works as the 1917 version of the Pier and Ocean theme (page 95), the experiments with color to such pictures as the *Oval Composition* and *Blue Façade* of 1913/14 (page 89). The result no longer arises out of a visual perception, however, but out of the basic material of his visual language: the straight line, the right angle, and the three primary colors and non-colors.

Composition: Checkerboard, Dark Colors

Painted 1919
Oil on canvas, 33 1/8×40 1/8"
Gemeentemuseum, The Hague
(Collection S. B. Slijper, on loan)

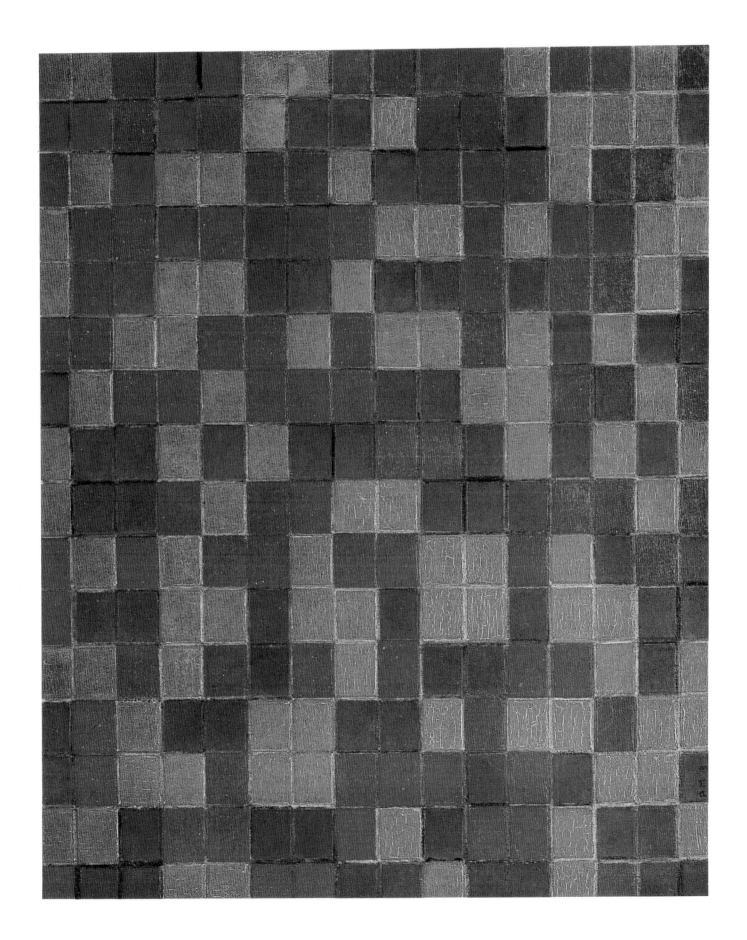

The experiments aimed at discovering a new, suprapersonal style, which were begun in 1917 with the founding of *De Stijl* magazine and the group of the same name, brought definitive results in Mondrian's work only in 1921. In the 1920 *Composition with Red, Blue, and Yellow-Green* a certain wavering can still be traced, both in the use of color and with respect to the predominance of the rhythm over the geometrical subdivision. A hesitancy of the same sort can likewise be found in the early works of 1921, to which the painting here reproduced belongs, whereas in the works that Mondrian did later in the same year he attained a classic equilibrium and complete certitude.

To be sure, in the work of early 1921—the present *Composition,* for example—some definite differences can be seen from the immediately preceding phase so clearly represented in the 1920 painting. The most striking aspect is the strong accent that Mondrian now places on the linear structure, that is, the lines bounding the planes. They have become much wider than in previous works, but are all in a uniform dark blue-gray, a sort of anthracite color, which makes them stand out against the primary colors red, yellow, and blue as well as against the two different shades of light gray-blue, but above all against the black, which, to my knowledge, appears for the first time in this work and another one of the same period as an area among the primary colors.

Another notable feature of this *Composition,* and one that continues into the works coming after it, is the dominant role played by the red area, upper left, with respect to the whole. The compositional use of this area, which is not precisely a square but has that effect optically because there is no black line at the left, predicts a whole series of paintings whose character and harmonic force result from the dominating presence of one square.

A third characteristic of this picture, and again one that was to last well beyond the second half of 1921, is the fact that some lines break off shortly before reaching the edge of the painting, whereas the color of the adjoining area carries through to the edge. This effect was also employed by other of the Stijl painters, and the explanation has been given that it represented an unwillingness to divide up the picture completely into a sort of trellis. In Mondrian's case, it seems to me rather a return, as so often with him, to earlier practices, this time to his late cubist compositions and the 1919 lozenges (page 101), in which, especially in the bottom half of the canvas, the structure does not reach the edge, thereby giving the whole a hovering, immaterial quality. The most characteristic feature for the first half of 1921, however, is a certain wavering in defining the colors, a hesitation in establishing the color elements.

Composition with Red, Yellow, and Blue

Painted 1921
Oil on canvas, 18 7/8 × 18 7/8"
Collection Mr. and Mrs. Herbert M. Rothschild,
Ossining, New York

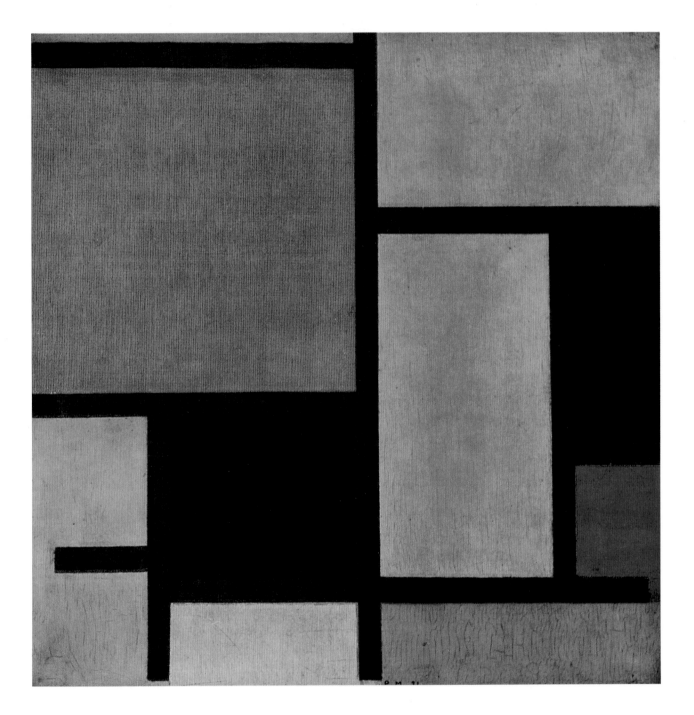

There is a clearly marked difference between this *Composition* and that of the first half of the same year, 1921. An elementary triad of colors has now been decided on. This decision, which Mondrian had arrived at empirically in 1921, was formulated in 1926, with the help of his friend Michel Seuphor, in a little statement of neo-plastic principles, the first paragraph of which runs: "The plastic medium should be the flat plane or the rectangular prism in primary colors (red, blue, and yellow) and in non-color (white, black, and gray). In architecture, empty space counts as non-color. The material can count as color" (Seuphor, *Mondrian,* p. 166).

Another aspect of the same development reached by Mondrian in this critical year of 1921 is outlined in the second paragraph of the statement: "There must be an equivalence of plastic means. Different in size and color, they should nevertheless have equal value. In general, equilibrium involves a large uncolored surface or an empty space, and rather small colored surface or space filled with matter."

This description of the equilibrium that Mondrian aimed at in his canvases could almost serve as a description of the painting reproduced here: the composition is carried by a square with no color (the "large uncolored surface"), and the small areas of color (upper left, red; outer right, blue; lower left, blue-black; and bottom center, yellow) balance each other completely despite their difference in size. Another typical feature is that the white area forming the painting's center of force is not a geometrically precise square but has the optical effect of a square, a fact reminiscent of the small deviations from geometry that Ictinus and his workshop employed in building the Parthenon in Athens, precisely in order to obtain the optical suggestion of complete regularity.

Moreover, it is striking to see how Mondrian, in a very short period of time, has arrived at an effect that is so much loftier and more monumental than before. The subdivision of the planes is now on a larger scale, and the color harmony is tighter and simpler; otherwise, however, this painting is closely related to the preceding one. Here too there is a blue-gray color contrasting slightly with the white and with the primary colors; here too the black lines do not always run to the edge of the canvas. And yet the viewer, comparing the two works, will have a definite feeling that a threshold has been crossed during the interval between them, that it is with the painting from the latter half of 1921 that the series of masterpieces commences upon which Mondrian's fame truly rests.

Composition with Red, Yellow, and Blue

Painted 1921
Oil on canvas, 15 1/2 × 13 3/4"
Gemeentemuseum, The Hague
(Collection S. B. Slijper, on loan)

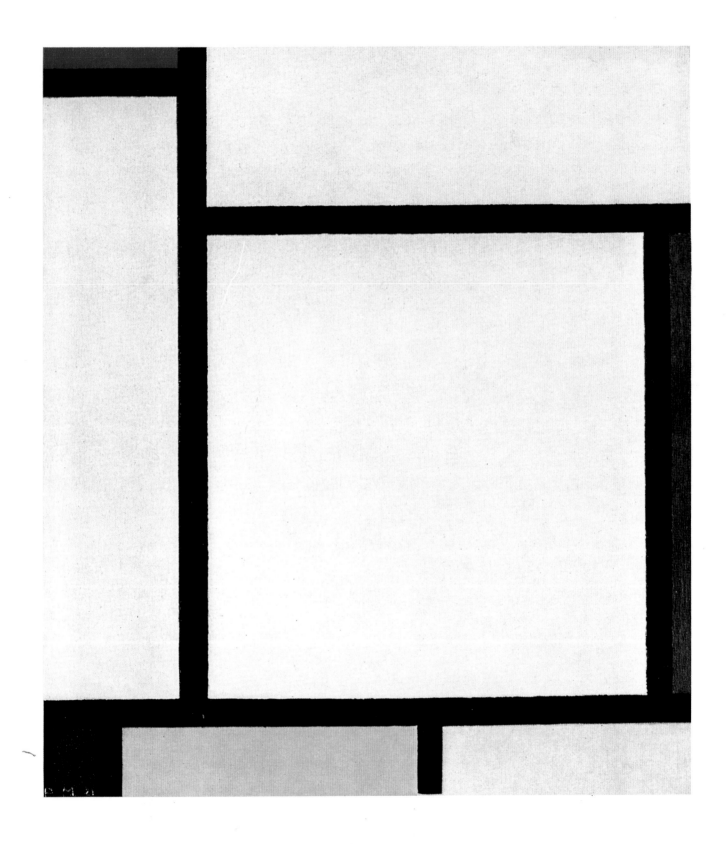

The year 1922 was an important one for Mondrian. On March 7 he celebrated his fiftieth birthday, an event that in the Netherlands still counts as a significant milestone in a human life. A number of his Dutch friends—Peter Alma, J. J. P. Oud, S. B. Slijper, and some others—took advantage of the occasion to organize a retrospective exhibition of his work in the Amsterdam Stedelijk Museum, from March 4 to April 2. It was the first and last retrospective exhibition of his work that Mondrian was to see. His two one-man shows in New York in 1942 and 1943 contained only work done in his last years, and the survey exhibitions in the Museum of Modern Art in New York from March to May 1945, and in the Amsterdam Stedelijk Museum in November and December 1946, came after his death. The 1922 show, intended in part to help Mondrian out of his economic difficulties, failed to attain that goal; nor did an exhibition of some of the works, taken over by the Parisian art dealer Léonce Rosenberg and shown in his gallery, bring Mondrian the financial relief that his friends had hoped for. During his Paris years, just after the economic failure of the exhibitions, Mondrian had to resort to painting flowers in the manner of his naturalistic watercolors of the early 1900s (figure 56), which his Dutch friends then sold to acquaintances and admirers of the artist for thirty or occasionally forty guilders. But Mondrian was always careful to separate this breadwinning activity from what he called his "own work": continuing and perfecting neo-plasticism. In 1925, he abandoned this indirect form of aid and, despite poverty and privation, devoted himself exclusively to his own work.

An outstanding example of this "own" work, dating from 1922, the year of his fiftieth birthday, is the painting reproduced here, which again marks a step forward from the preceding one. The equilibrium of the planes and colors is reduced still further to the basic elements; over against the three primary colors, which now form a perfect triad, stand the bright white as a non-color and the tautly drawn black lines. The equilibrium is now pre-eminently qualitative, that is, a balance of weights not of dimensions, an equilibrium that from the outset excludes any symmetry. Mondrian proceeded after 1922 along this road, the road of purification, of reducing the plastic means to the elements, always constructing each new masterpiece on the basis of the one before. Although there may seem to be little variation in his work, every painting surpasses its predecessor in purity and mastery.

Composition

Painted 1922
Oil on canvas, 15 × 13 3/4"
Collection Mr. and Mrs. Herbert M. Rothschild,
Ossining, New York

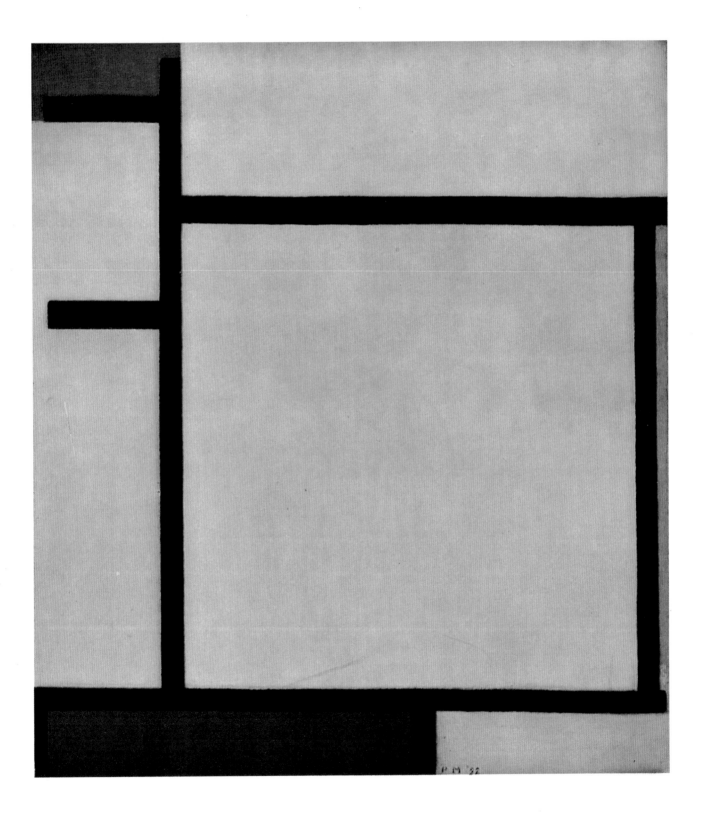

Composition in a Lozenge

In 1925 Mondrian resumed the lozenge-shaped composition that he had not practiced since 1921, returning to the series represented here by the lozenge-shaped composition of 1919 (page 101). This return was in no way accidental; it was closely tied up with events within the Stijl group and the controversy that arose in the mid-twenties between Theo van Doesburg and Mondrian.

In 1924 Theo van Doesburg, in order to lend a new dynamic accent to the art of De Stijl, had brought the diagonal back into his paintings. Perhaps the first and most evident instance of this change, aimed indirectly at Mondrian and the metaphysical implications of his art, is the *Counter-Composition* of 1924, now in the Stedelijk Museum in Amsterdam, followed by a similar work of 1925 (figure 48), now in the Hague Gemeentemuseum. In an article in *De Stijl*, van Doesburg explains his new principle as follows: "Elementary (anti-static) counter-composition. Adds a new oblique dimension to orthogonal, peripheral composition. Thereby solves the horizontal-vertical tension in a realistic way. Introduction of inclined planes, dissonant planes, in opposition to gravity and architectonic-static structure. In the counter-composition, the equilibrium of the plane plays a less important part. Each plane has its share of the peripheral space, and the construction should be regarded more as a phenomenon of tension than as a phenomenon of surface relationships" (*De Stijl*, VII, 39). Somewhat later van Doesburg begins an article on "elementarism," his new form of the art of De Stijl, with the following words: "Elementarism was born in part as a reaction to an all too dogmatic and often shortsighted application of neo-plasticism, in part as a consequence thereof, and finally and principally as a strict correction of the neo-plastic ideas" (*De Stijl*, VII, 83–84).

The lozenge-shaped composition of 1925 is Mondrian's answer to van Doesburg's action, which Mondrian, not altogether without justification, felt as an attack. In this lozenge-shaped composition and the six others dating from the same year and the two that followed, he wanted to stress the equilibrium that could be attained with simple contrasts, vertical and horizontal lines, without losing any of the dynamics of the balance. In this way he also achieved another goal which he had had in mind since 1917, since his first composition with color planes (page 97): expansion of the rhythm beyond the surface of the picture, outside its edges, since the contrast of vertical and horizontal lines in the lozenge form is less cramped and restricted by the frame. Out of this protest, therefore, one more step forward emerged.

Painted 1925
Oil on canvas, 42 7/8" diagonal
Private collection, The Netherlands

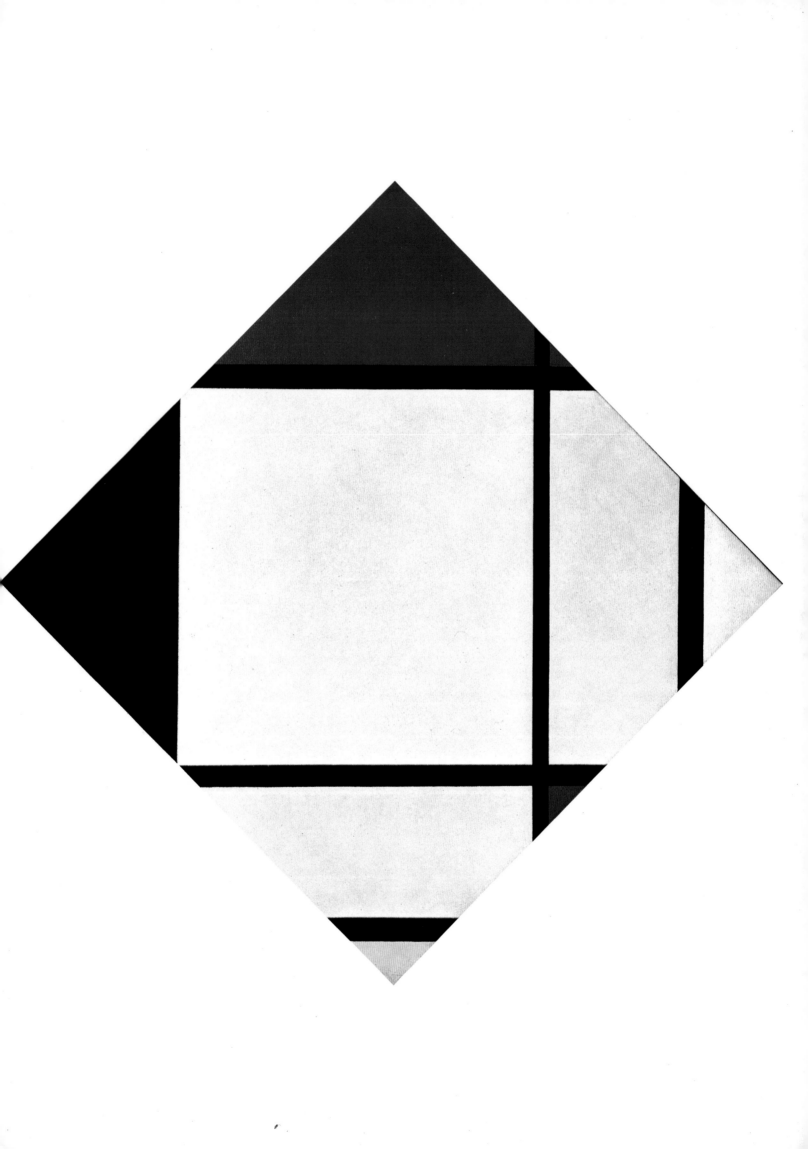

Composition with Red, Blue, and Yellow

Around 1930 Mondrian's art attained a highpoint of purity and sobriety, for which the groundwork had been prepared in the paintings of the previous years, the 1929 *Composition,* for example. Actually, the painting reproduced here is a variation on the picture of the preceding year, at least in so far as the linear framework is concerned. But for that very reason the subtle differences in the work—such as the subdivision of the left strip of the painting into three unequal rectangles, one of which is the blue square—are all the more remarkable. They show that there can never be any question in Mondrian of a preconceived pattern for a composition, but that every work arises out of cautious and painstaking association with the elements of painting, which must be resolved anew in every work.

Especially noteworthy in this work is the large red square in the upper right corner which, like the white square in the painting of the previous year, is bounded by only two lines within the painting and thus has a tendency to grow further, in rhythmic expansion, beyond the edge of the canvas. The large area of a brilliant primary red gives this work a strong accent in the major mode. This quality is all the more striking in a canvas dating from 1930, since in the same year Mondrian also produced paintings of an extreme sobriety, such as the two compositions with black lines, one of which is reproduced above (figure 50). There, he avoided the use of color completely; the contrasts of the lines, whose thickness also varies, determines the character and balance of the composition.

Basically, this *Composition No. 2 with Black Lines* is likewise a variant of the painting reproduced here and of its 1929 precursor, since the main element in all these works is an open square. In the Eindhoven painting, as well as in its counterpart in the United States, however, there is an inversion of the composition (as can be done with a melody in music). The open square is now not in the upper right but in the lower left, and this shift of the accent certainly contributes to the changed harmonic mood of the painting. If we compare the composition that is reproduced here, with the red square, to a musical *allegro,* the *Composition with Black Lines* might be likened to a *largo.*

Comparison of these two paintings done in the same year will in any case make evident how many possibilities of variation and difference there are in Mondrian's art, how it was always possible for him, on the basis of the elementary means of the plastic language, to attain a new and original result.

Painted 1930
Oil on canvas, 20 1/8 × 20 1/8"
Collection Mr. and Mrs. Armand P. Bartos, New York

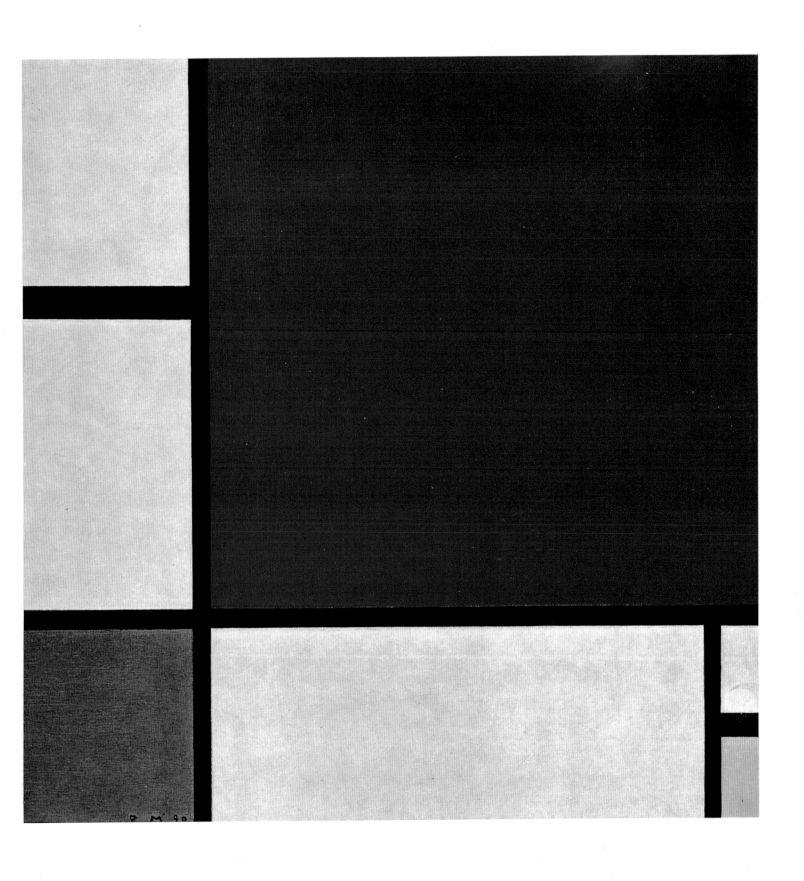

Composition with Yellow Lines

Painted 1933
Oil on canvas, 44 1/2" diagonal
Gemeentemuseum, The Hague

This lozenge-shaped *Composition with Yellow Lines* is the ultimate state in a sobering process, earlier phases of which are exemplified by the nearly square *Composition No. 2 with Black Lines* of 1930 (figure 50) and such other lozenge-shaped compositions as *Fox Trot A* of 1927, now in the collection of Yale University, and the 1931 *Composition with Two Lines.* The last-named work was commissioned by the architect Willem M. Dudok for the Town Hall in Hilversum, which he designed, and is now on loan to the Amsterdam Stedelijk Museum.

The painting reproduced here is very important in Mondrian's *oeuvre*, both as a link to the past and as a connection with a still distant future. It is the only work since the origin of the neo-plastic pattern of composition in 1918 and its perfection in 1921, as far as I know, in which the lines on the painting do not intersect. In a sense it harks back to the maximum expansiveness of the 1917 compositions with color planes. The square implied by the lines on the lozenge-shaped canvas reaches out beyond the edges of the painting to form a plane of which the actual surface of the picture is only a fraction. Referring to Mondrian's *Composition I/1925* in an article for the 1956 *Jahresbericht der Zürcher Kunstgesellschaft,* Max Bill called attention to this remarkable compositional phenomenon, which in no other painting by Mondrian is as prominent as in the one reproduced here.

Another noteworthy aspect of this work, again reminiscent of the 1929 and 1930 paintings, is the difference in thickness and weight of the four yellow lines that constitute the composition. This is the way in which Mondrian goes about making good his 1926 avowal: "All symmetry shall be excluded." He arrives at an equilibrium without starting from identical elements; his equilibrium is thus typically qualitative.

At the same time, this painting is the last link during his Paris period in his resistance against the elementarism of Theo van Doesburg, the founder and motive force of De Stijl, who had died in 1931. But Mondrian still wanted to show the fundamental correctness of the horizontal-vertical opposition, even in a lozenge. Later he wrote: "In his late work van Doesburg tried to eliminate static expression by a diagonal arrangement of the lines of his composition. But this accent destroys the feeling of physical equilibrium that is needed for the enjoyment of a work of art. If a square painting is hung diagonally, however, this effect is not produced" (*Museum of Modern Art Bulletin,* 1946, no. 4/5, p. 35).

Finally, the picture reproduced here points to the future, by the exclusion of black. This anticipates the post-1941 paintings and is thus connected even with the *Victory Boogie-Woogie,* Mondrian's last work, which is also lozenge-shaped and contains no black.

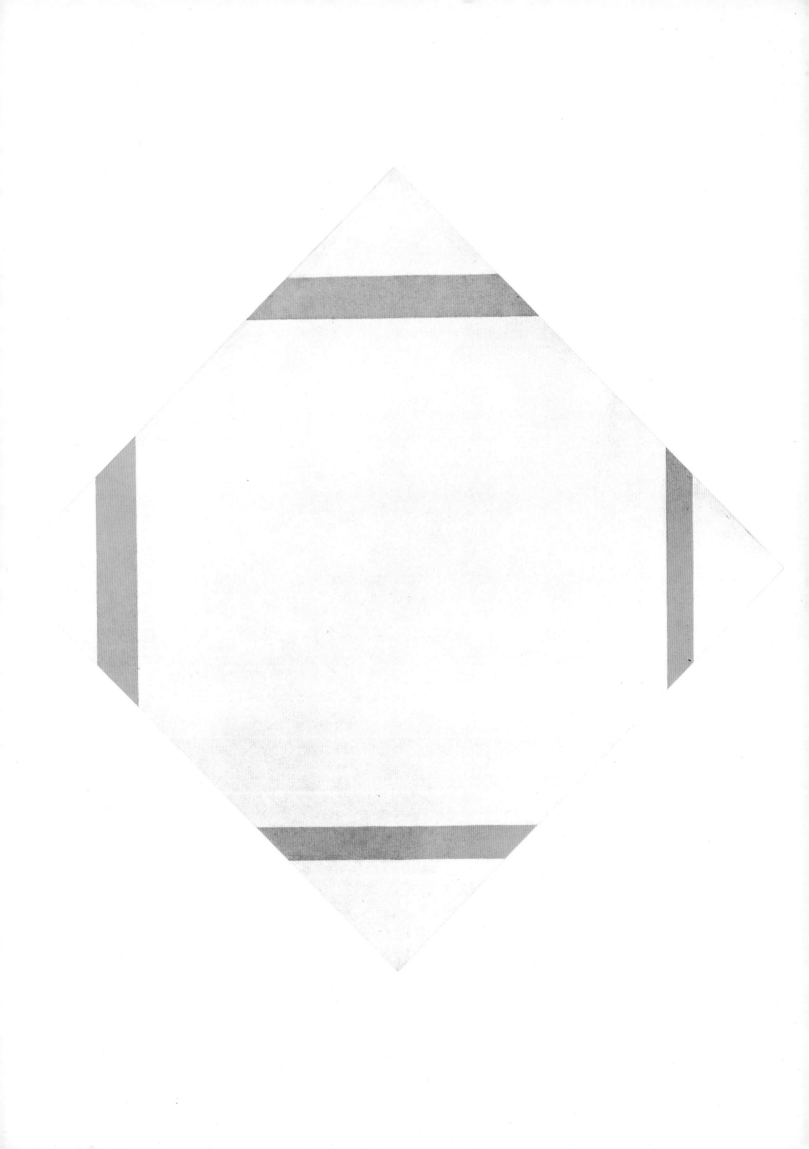

Composition with Red and Black

The years from 1933 to 1938, which Mondrian spent in Paris, are marked by a series of compositions in which the linear element sets the tone and color is more or less reduced to an accompanying voice. The origin of these linear compositions is to be found in the series of paintings of 1930 and the following years in which the tension and nuances of the lines constitute the most important compositional elements; the consequences of these works are to be seen in the development of Mondrian's art.

In 1932 Mondrian used double lines for the first time, and in a manner suggesting that it was an experiment. This way of enriching, and complicating, the composition thereafter came to occupy an important place in his paintings. Many of the works based on this compositional principle were, however, altered by Mondrian himself, after he left Paris, in accordance with a subsequent stylistic phase. This change consisted mainly in the addition of colored planes that are not bounded by black lines and thus do not form an indissoluble whole with the linear framework of the canvas. In the case of these altered paintings, which always have two dates, the year they were begun and the year of their completion, we sometimes have to go back in thought to the two 1917 *Compositions in Color*, to which this phase of Mondrian's work seems to refer, although this reaching into the past was almost certainly not conscious on his part.

As a result, works from the years around 1935 to 1938 are relatively rare, at least in their original state; for the five years from 1934 through 1938 I know of only twenty-three. The *Composition with Red and Black* is one of the best representatives of this period, although the general structure goes back to older works. The basis of the composition is still an enclosed square, as in the compositions dated 1921 and 1922 (pages 107, 109), however with this difference, that the square is still further subdivided and enlivened by three horizontal lines. Here a compositional pattern re-emerges that in essence goes back to the lozenge-shaped compositions of 1918 and 1919 (page 101), in which squares are brought together into larger units or, if you will, in which larger squares are divided up into smaller units. The sparing use of color accentuates the compositional force of the lines still further.

The subtlety of Mondrian's feeling for compositional equilibrium appears in many details, one of which may be mentioned particularly here: of the three lines that subdivide the square at the lower right, the center one, which does not cross the right-hand vertical line, is a fraction thicker than the others. It is details like this that made it possible for Mondrian to attain perfect equilibrium and make harmony visible.

Painted 1936
Oil on canvas, 23 1/4 × 22 1/4"
Sidney Janis Gallery, New York

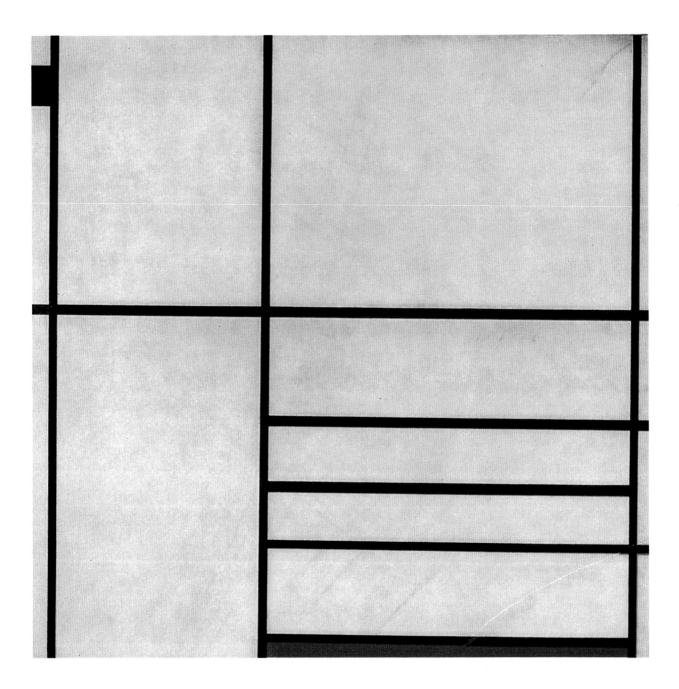

This 1936 painting is the only one of a series of three that Mondrian did not retouch and alter after leaving Paris. The other two pictures, both begun in 1935 and completed in 1942, as the signatures inform us, have been essentially changed in appearance by the addition of unconnected color planes and the reinforcement of some of the black lines.

These three paintings, which represent an entirely distinct category in the body of Mondrian's work, have two features in common: their format, which is twice as high as it is wide, and the fact that the two vertical lines are not connected. The strongly dominant vertical effect thereby created seems at first sight to contradict Mondrian's aims, for one of his major artistic and philosophical purposes was to eliminate the tragic from painting and from life. On a page from a sketchbook dating from the mid-1920s, Mondrian jotted a note explaining his concept of the tragic as "suffering because of the domination of the one over the other." Such a situation of domination arises in this 1936 composition: the vertical accent (to Mondrian, symbol of the masculine) prevails over the horizontal (the feminine).

Mondrian assuredly felt the dominance of the vertical element in this trio of paintings and in order to counteract it presumably made the changes in the two 1935/42 canvases, introducing horizontal accents in color and strengthening the horizontal lines. But the painting reproduced here, although conceived later than the other two versions, escaped these modifications and thus shows the original state of a phase, albeit a brief one, in Mondrian's development.

It is impossible to know to what extent the unusual compositional pattern of these "tragic" paintings is bound up with the situation of the years 1935 and 1936, with their menace and inherent tragedy. These pictures are, however, directly related to the 1933 lozenge-shaped painting with four yellow lines (page 115), by virtue of the fact that the composition overshoots the boundaries of the canvas. Like the yellow lines, the white shaft between the two vertical lines is not restricted by the edges of the painting but moves out and away into the space beyond. Here too we have a distinguishing feature of the first Stijl period, expansiveness, vitally operating to alter Mondrian's work with retroactive power.

Vertical Composition with Blue and White

Painted 1936
Oil on canvas, 47 5/8 × 23 1/4"
Kunstsammlung Nordrhein-Westfalen, Düsseldorf

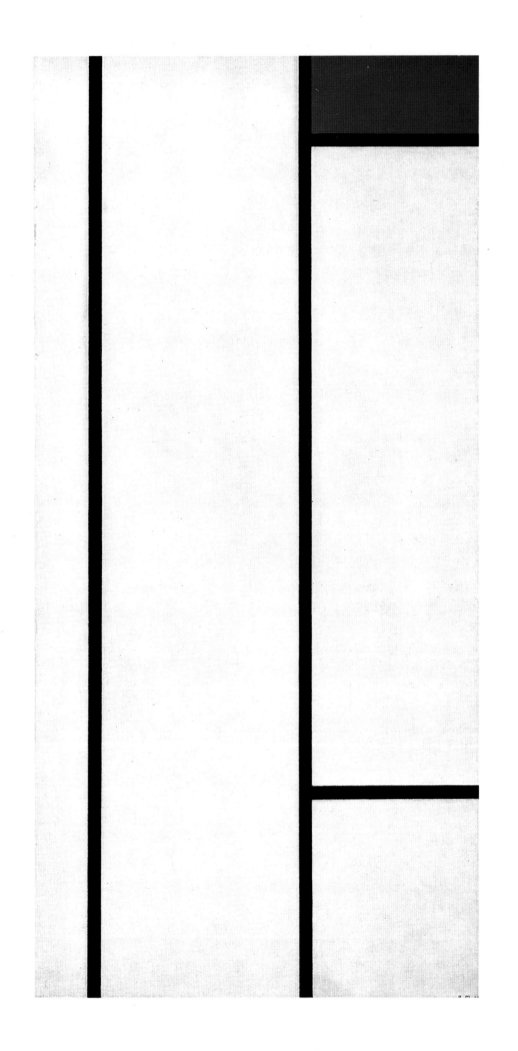

Composition London

Painted 1940/42
Oil on canvas, 32 1/2 × 28"
Albright-Knox Art Gallery, Buffalo, New York

In the autumn of 1938, just after the dramatic and tragic days of the four-power agreement in Munich concerning Czechoslovakia, Mondrian left France, feeling that war was imminent and that Paris was easy prey for the Nazis, especially for their Luftwaffe. He also knew that he was saying his last farewell to Paris when he set out for London on September 21, 1938. His original intention was to go to the United States as soon as possible, but his friends in London—Naum Gabo, Barbara Hepworth, Leslie Martin, Ben Nicholson—gave him such a warm and heartfelt reception, found a studio for him, and saw to it that some of their friends bought paintings from him, that he began to feel completely at home. He had a little studio at 60 Park Hill Road, in Hampstead, very near the studios of Nicholson and Barbara Hepworth, where he was able to work quietly without being disturbed.

But the war came to Mondrian and drove him out of London as he had feared he would have been driven from Paris, under the bombs of Nazi warplanes. At the end of September 1940, after long hesitation, he left for New York. His stay in London had lasted almost exactly two years. During this time he had conceived a number of paintings, but had completed only a very few of them, such as the 1939 *Composition with Red* (figure 47), of a compositional type related to the 1935 *Composition with Red and Black* (page 117). Some of the paintings begun in London were found still unfinished in his New York studio after his death in 1944. Other canvases sent to him from London he did complete in New York.

Composition London is a typical example of the pictures that Mondrian conceived shortly before he left England and completed in New York. It is dated, at the lower right, 40/42, and from this can be identified as the painting exhibited as No. 11 in Mondrian's first one-man show in New York in 1942. The changes he made in New York are all of the same sort: to compositions closely related to the canvases of 1936 and later, Mondrian added small, free-standing, unbounded areas of color. These colored areas give the whole a new vivacity; they break the strict, almost somber aspect of the pictures of the late thirties and introduce a new, lively, sparkling rhythm anticipatory of such works as *Broadway Boogie-Woogie* and revealing the same inspiration. The influence of the thirties remains, however, in the strongly asymmetric composition, with a concentration of accents primarily on the right. This asymmetry was to give way in New York to another, highly rhythmic compositional structure.

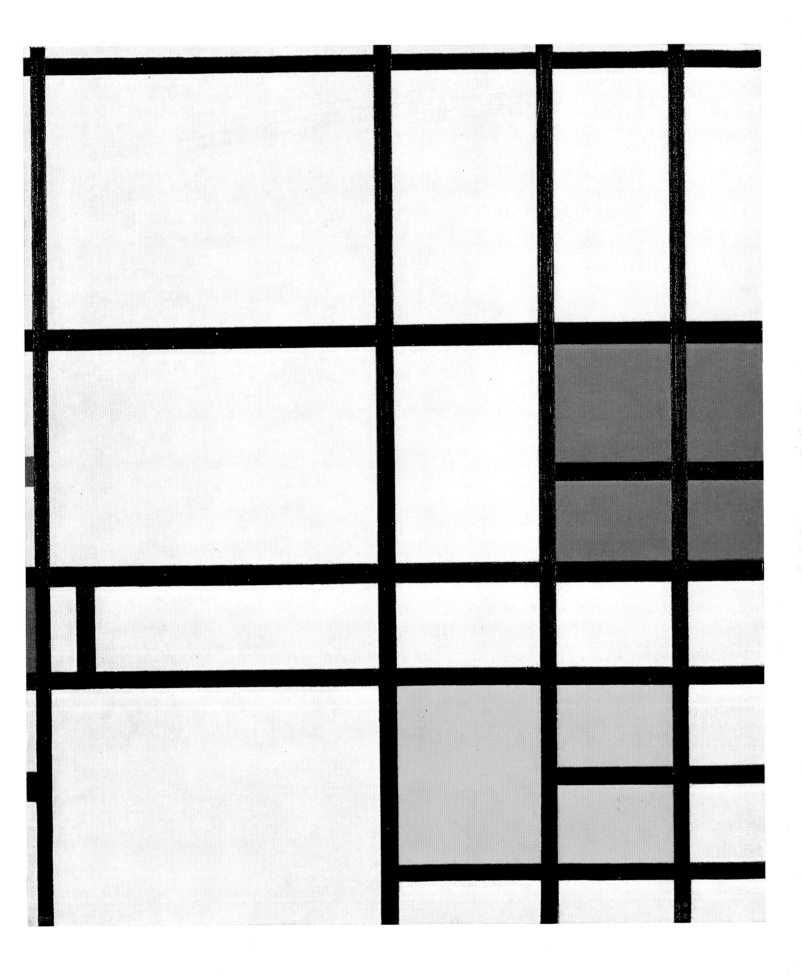

New York City I

Painted 1942
Oil on canvas, 47 1/4 × 56 3/4"
Sidney Janis Gallery, New York

New York City I, or rather the series of works later brought together under the title *New York City,* marks the beginning of a new phase in Mondrian's work. The black lines have disappeared along with the rectangles of primary color, which since the 1918 *Composition: Color Planes with Gray Contours* (page 99) had formed a solid flat totality with the lines and the white that had previously been the background. Instead, lines in the primary colors—yellow, but also red and blue—traverse the square canvas, interweaving with each other.

For the most part, the yellow lines cross those of the other colors, but here and there, in a most subtle way, the red and blue lines cross the yellow. Yet this style does not give rise to an illusionary space; the colored bands over- and underlap one another on the surface, before the eyes of the viewer. It is quite reasonable to accept Michel Seuphor's suggestion and attribute this effect of crossing and interlacing to Mondrian's method of conceiving and working out these pictures: he used strips of colored paper (which are still attached to two other, unfinished versions of the same composition; see figure 51) and moved them about on the canvas to get the effect he wanted. In this way he almost automatically introduced the crossovers and the suggestion of interwoven colored bands.

This technique was one of the reasons for the change in Mondrian's style and manner of working after his arrival in the United States, just as the *papiers collés* technique marked a transition between the analytic and synthetic phases of the cubism of Picasso and Braque. The other reason for the change, which some of his European followers regarded as a departure from his own principles, was the inner liberation he felt after his move to America. The atmosphere he encountered there was not filled at all times with a feeling of menace and dread, but with a solid confidence in final victory over the tyranny that had driven Mondrian from Paris. As a result his pictures of the American period have a different tonality, in major as it were, compared with the somber canvases, dominated by black lines, of the end of his stay in Europe.

Moreover, in the brisk *allegro* rhythm of these paintings there is a new feeling for harmony, which Mondrian could have learned only in his new surroundings: the rhythm of the modern metropolis. In the early days of De Stijl, Mondrian and his friends had striven to have the human environment, the great city, determined by the laws of harmony. Now, an example of this new cultural pattern, New York City, had a radical influence on his painting.

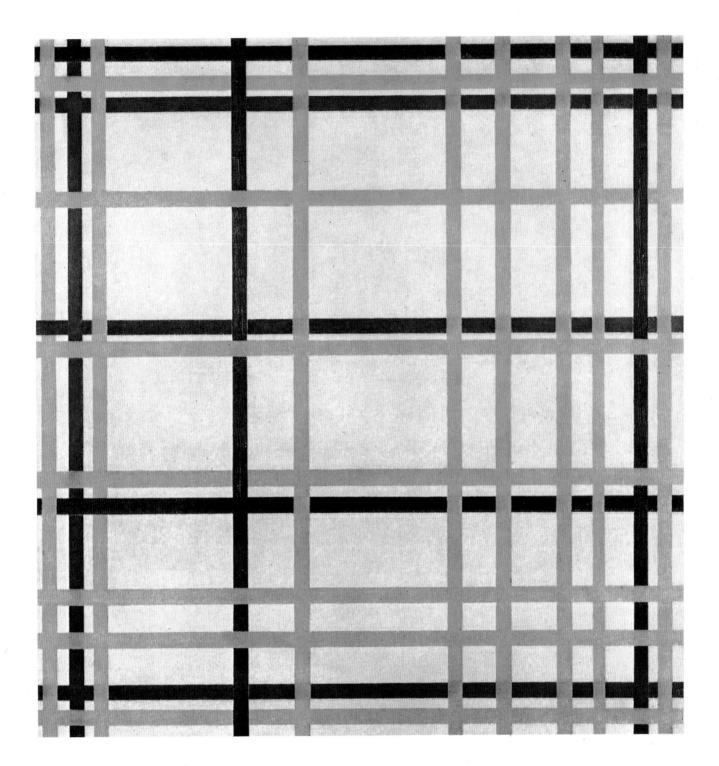

Broadway Boogie-Woogie

Painted 1942/43
Oil on canvas, 50 × 50"
The Museum of Modern Art, New York

Broadway Boogie-Woogie is the last painting Mondrian completed. In the early phases of its genesis, the two 1942 drawings in the Newman Collection (figures 53, 54), it still shows many points of coincidence with the painting that preceded it, *New York City I*. In the preliminary studies the rhythm of the painting is determined by the long lines of the grid, while other accents indicate the insertion of little bands of unbounded color, characteristic of the enlivening alterations that Mondrian made in New York on the paintings of his last years in Europe. One example of a painting so changed is *Composition London* (page 121), which in its present state—that is, after the changes Mondrian made on it in New York—must be roughly contemporaneous with the *Broadway Boogie-Woogie* sketches.

In the completion of *Broadway Boogie-Woogie* the same sort of process took place as in the final reworking of *Composition London*. The painting seems initially to have been based on lines, mainly yellow, running through it (and in this respect closely related to *New York City I*) and on some connecting bands of different color, which brought about a change in direction and proportion. To this basic composition were added small blocks of red, blue, gray, and sometimes the same yellow as the traversing lines, giving the whole a new tempo, an entirely unexpected movement, a bouncing staccato rhythm. This new tempo is perhaps the most striking aspect. Whereas Mondrian's early paintings were built up out of long continuous lines and large planes, which could be compared to whole or half notes in music, there now appear much smaller forms, comparable to eighth and sixteenth notes, contrasting only here and there with larger areas. This innovation, which evidently took place while Mondrian was working on the painting, gives the canvas a new and sparkling vivacity.

One of the reasons for this renewal in Mondrian's work is without doubt reflected in the title: boogie-woogie music, with its unexpected syncopation of rhythm, is elaborated visually in this painting. Passionately devoted as he was to dancing and rhythm, Mondrian had always been attracted by the latest in ballroom music, advocating the tango and one- and two-steps over the waltz. In the late 1920s he named two paintings *Fox Trot A* and *B* after the popular American dance recently introduced into Europe. And boogie-woogie obviously had a profound impact on him. Nevertheless, the most important factor in the origin of this painting, and of the "mutation" in his art, must have been the experience of the daily rhythm of New York itself, the pulsating movement that animates Broadway, especially at night, and, in thorough keeping with the old principles of De Stijl, creates a harmony out of the opposition of contraries.

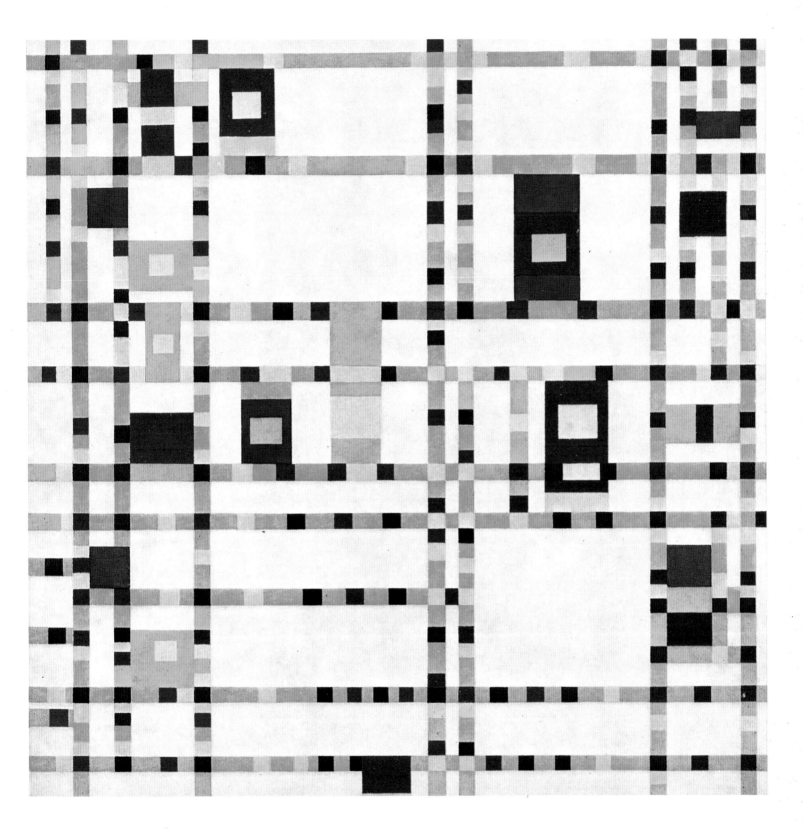

Victory Boogie-Woogie, a painting that Mondrian conceived in expectation of victory in World War II and that remained unfinished by reason of his death on February 1, 1944, adds immeasurably to the innovations of his American period. Even in its half-finished state, the painting shows an enormous enrichment over the 1943 drawing (figure 52) containing a first design for the work. It is remarkable to see how Mondrian, already over seventy, was capable of a liveliness, a receptivity to new impressions, a suppleness in dealing with his own approach—all sharply in contradiction to the reputation for dogmatism that surrounded him and that he had himself furthered in the years after 1925, in his dialectic controversy with Theo van Doesburg. No, Mondrian was not doctrinaire in any sense of the term, but he did go constantly further on his own way, and the changes that took place in his work were not deviations from a dogmatic policy but consequences of the insights and experiences deriving from his eyes and his "thinking with his eyes," as Cézanne put it. Victory Boogie-Woogie is a fascinating and convincing example of this development.

It may be a mistake to judge Victory Boogie-Woogie as an actual painting, since it is, quite literally, work in progress. Yet the picture as it stands reveals a number of innovations that go considerably beyond Broadway Boogie-Woogie. First of all, the strictly linear pattern that is so marked a characteristic of New York City I and that is still dominant in Broadway Boogie-Woogie is of far less importance here. Instead of a flowing movement, a syncopated movement now predominates; the beat of the measure dissolves into shifts of accent.

Many commentators on this painting have seen in it a reflection of New York, of the rhythmic swarming of the great city with its giant buildings and straight streets. In my opinion this approach is as misleading as the attempt to see a reflection of the Dutch landscape in Mondrian's paintings of the twenties. Mondrian's Victory Boogie-Woogie seems to me to be not the reflection of something optically perceived but the depiction of a feeling for life, of a style of life: the joyous expectation, the sure hope of victory over tyranny, misrule, and personal glorification—a victory that Mondrian had been looking forward to since 1917. And it may also be symbolic that Victory Boogie-Woogie remained unfinished, as unfinished as the victory. In any event, it is the painting which ushers in the postwar evolution of art, with a younger generation now leading the way in the direction that Mondrian found the only one to take: Always further!

Victory Boogie-Woogie

Painted 1943/44 (unfinished)
Oil and paper on canvas, 70 1/4" diagonal
Collection Mr. and Mrs. Burton Tremaine,
Meriden, Connecticut

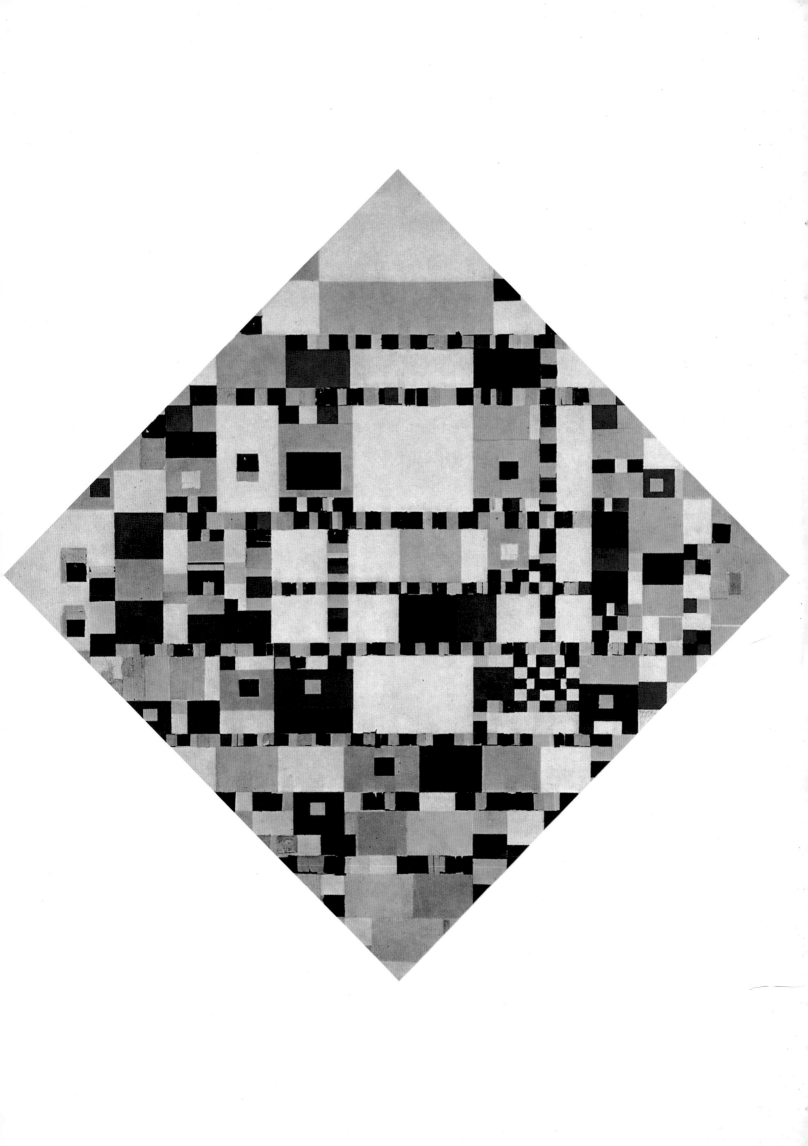

Foto Attualita, Venice: fig. 47; Martin F. J. Coppens, Eind-
hoven: fig. 50; A. Frequin, The Hague: fig. 29; Giraudon,
Paris: fig. 62; Fritz Glarner, New York: fig. 13; Yves Hervo-
chon, Paris: fig. 40; Harry Holtzman, Lyme, Conn.: fig. 31;
Michel Seuphor, Paris: figs. 1, 3, 6, 12; M. Woldringh, Leiden:
pages 51, 52, 57, 59, 63, 69, 71, 73, 77, 79, 83, 85, 89, 93, 97,
99, 103, 111, 115, 125.